IMAGES
of America
DETROIT
1930–1969

All of the photographs used in this book come from the Photograph Collection of the Burton Historical Collection at the Detroit Public Library.

IMAGES
of America

DETROIT
1930–1969

David Lee Poremba

ARCADIA
PUBLISHING

Published by Arcadia Publishing
Charleston, South Carolina

Printed in the United States of America

Library of Congress Catalog Card Number: 99063928

For all general information contact Arcadia Publishing at:
Telephone 843-853-2070
Fax 843-853-0044
E-mail sales@arcadiapublishing.com
For customer service and orders:
Toll-Free 1-888-313-2665

Visit us on the Internet at www.arcadiapublishing.com

To my family, especially my new grandson, Connor.

CONTENTS

INTRODUCTION

As the Roaring Twenties came to an end and the new decade dawned, the United States found itself locked in the grips of the Great Depression. The City of Detroit was no exception as industry laid off workers and unemployment and bread lines formed across the city. There were a few bright spots around town where Detroit showed the world its ambition and ingenuity. In October 1929, the Ambassador Bridge opened to traffic and just 13 months later, in November 1930, so did the Detroit-Windsor Automobile Tunnel. Detroit mayor Frank Murphy led the country in supporting state and federal welfare programs to help people through the economic crisis.

By the middle of the 1930s, Detroit began picking itself up out of the economic mud and was soon flexing its industrial muscle as manufacturing, led by the auto industry, put the Motor City back into shape. As the decade ended and world war approached, the city was ready to take its place on the world stage.

The country reeled from the shock of the attack on Pearl Harbor and had to shift its industrial might from civilian use to the war effort. Nowhere was that shift more evident than in Detroit. The city's huge manufacturing capabilities, when turned to the making of the implements of war, earned the city another nickname. The Motor City became the Arsenal of Democracy and began to evolve once more. The influx of workers from the Deep South to the war industry added yet another facet to the city's society and culture. But this evolution came about with a price. Reacting against racial discrimination and acute housing shortages, civil violence broke out in the summer of 1943. Both whites and African Americans vented their frustrations on each other with the sorrowful loss of life and property.

Under the leadership of Mayor Edward J. Jeffries Jr., the city attempted to make amends for its shortcomings, and great strides were made to improve the life of Detroit workers. Jeffries, having worked the line at the Ford Rouge Plant, was strongly pro-labor and pro-union and laid the groundwork for the next step in Detroit's growth.

As the Second World War came to a close and production re-tooled for the return to civilian life, an economic boom swept through Detroit. Returning veterans were absorbed into the work force, production figures soared, and the economy was moving. Real estate around the downtown area was developed as well as the suburbs, and the city proper tore down and developed itself. The freeway systems were started, changing old neighborhoods permanently and turning Detroit into more of a commuter city than anything else. The city celebrated its

250th birthday in 1951, prompting an outpouring of funds to build with. Major additions were made to the Art Institute, the Historical Museum, and the riverfront.

In June of 1953, Mayor Albert E. Cobo presided over the laying of the cornerstone of the new City-County Building at Woodward and Jefferson. It would be the second structure put up (the first being the Veteran's Memorial Building) in the new Civic Center area along the riverfront. Other developments would soon follow.

Mayor Cobo would not live to see the next step in Detroit's evolution. Mayor Jerome P. Cavanaugh presided over the city's further development and its attempt to burn itself down. The great Hall and Convention Arena named for Cobo was completed in the early 1960s. But a growing undercurrent of tension would soon change the city yet again. Racial discrimination against African Americans had long been ignored during the 1950s and early 1960s. The passage of the Civil Rights Act in 1964 did not do enough to improve relations. Violence broke out across the country, and the worst riot in the history of the United States occurred in Detroit in July 1967.

The photographs in this volume attempt to chronicle the history of the city during these decades of change and growth. This book ends in 1969, just before another step in the evolution of the area that began a rebirth of the City of the Straits.

One

THE 1930S

FRANK MURPHY, MAYOR OF DETROIT, 1930–1933. Born in Harbor Beach, Michigan, in 1890, Frank Murphy graduated from the University of Michigan with a law degree in 1914 and joined a law firm in Detroit. When the United States entered World War I, Murphy joined the Army and served as an infantry captain in France. After the war he entered private practice and taught law at the University of Detroit. From 1924 to 1930 Murphy served as judge on Recorders Court before resigning to run for mayor. As mayor, Frank Murphy earned a good reputation by helping people in Detroit who had lost their jobs during the Depression, and he was a strong proponent for state and federal welfare. Murphy resigned his office in 1933 when Pres. Franklin Roosevelt appointed him governor-general of the Philippines. Murphy was later elected governor of Michigan and served from 1937 to 1939.

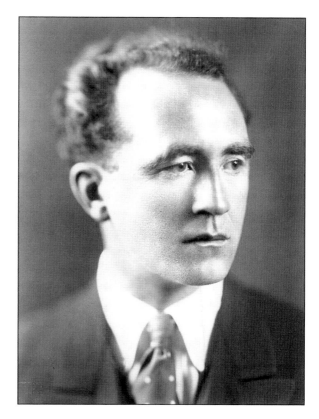

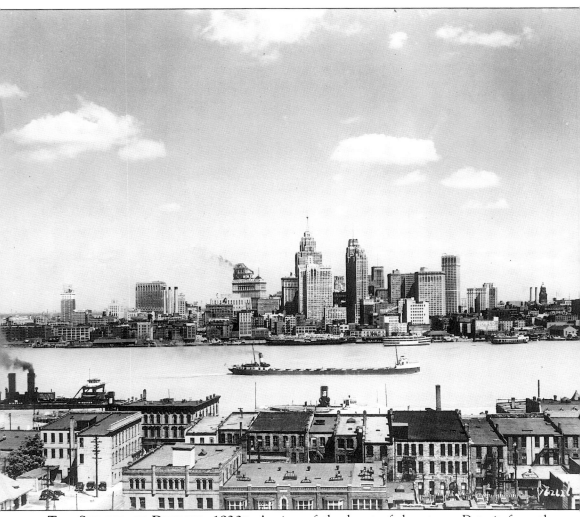

THE SKYLINE OF DETROIT, 1930s. A view of the heart of downtown Detroit from the Canadian side of the river shows off the cluster of high-rise buildings that make up the business district. The tallest building in the center group is the Penobscot Building, accompanied by the Guardian, Union Trust, and Barlum Tower. Just to the right of center is the Hudson's Building. In the grip of the Great Depression, Detroit was crippled with corruption, saddled with debt, and riddled with unrelieved unemployment. Still, it is business as usual albeit on a smaller scale. Excursion steamers and cargo vessels still ply their trades on the river.

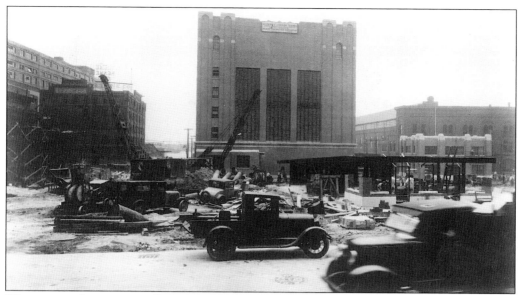

WOODWARD AVENUE AND RANDOLPH STREET, 1930. Construction of the Detroit to Windsor, Canada Auto Tunnel is underway. The tubes are in place under the river and the ventilation building (center) is finished. The toll booths and the rest of the entrance is being worked on to be completed in time for a November opening.

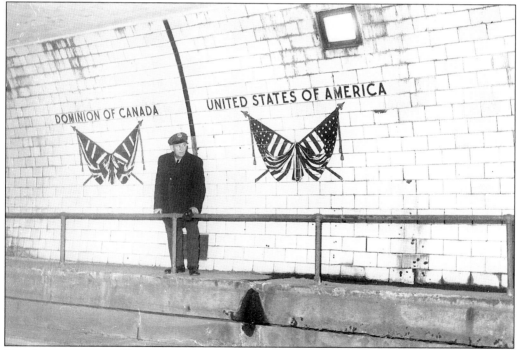

THE INTERNATIONAL BORDER, 1930. An employee of the Tunnel Company stands at the U.S.-Canada border beneath the Detroit River at the halfway point. The tunnel officially opened on November 1, 1930, and became a commercial success overnight. The first driver through was Joseph Zuccatto, a cement truck driver, working on the tunnel. He drove his truck through and back again to make sure everything was okay.

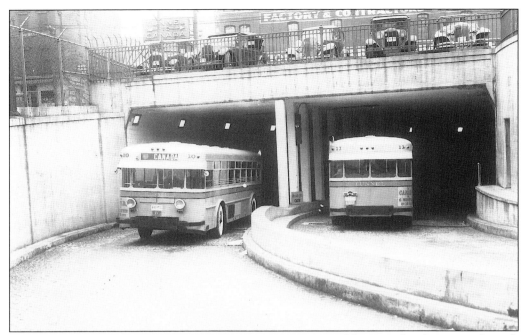

THE DETROIT-WINDSOR AUTO TUNNEL, 1930. Two tunnel buses make their way through the 5,160-foot-long tunnel beneath the Detroit River. There were 30 new buses operating through the tunnel from the heart of downtown Detroit to the heart of Windsor, Ontario. The construction of the tunnel took two and a half years.

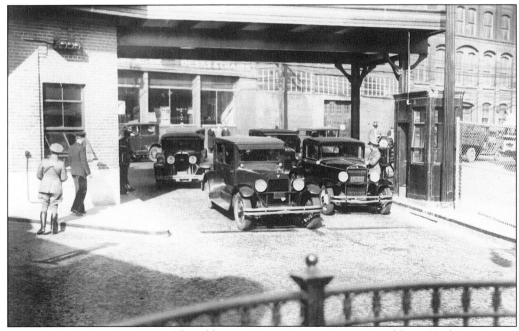

WOODBRIDGE STREET, 1930. The ribbon-cutting ceremony is over, and Pres. Herbert Hoover, in his office in Washington, D.C., has pushed a button to ring bells in Windsor and Detroit. Here, the first toll of 25¢ is collected, and the tunnel is open for business. Construction costs reached a staggering $25 million.

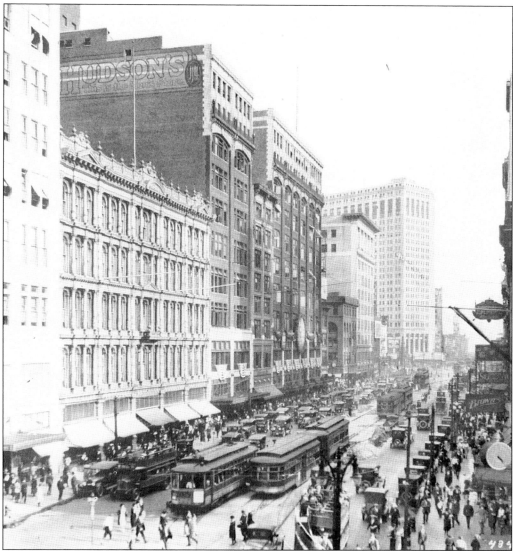

WOODWARD AVENUE, LOOKING SOUTH TOWARD THE RIVER, 1930S. A typical day in downtown Detroit sees office workers and shoppers on the sidewalks and motor traffic filling the streets. One lane in each direction took care of automobile traffic, while in the middle of Woodward Avenue, the same held true for the streetcar lines. In the foreground are two double-decker sightseeing buses that are modeled after their English counterparts. This is the center of the Motor City's retail district, headed by the J.L. Hudson Company. In competition with them are Kern's, Woolworth's, Kresge's, Klines, and an assortment of shoe stores, jewelers, milliners, and haberdashers.

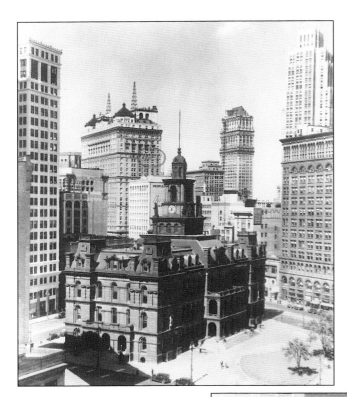

MICHIGAN AND WOODWARD AVENUES, 1931. City hall still stands grandly amidst its new high-rise neighbors. To the right can be seen the Majestic Building, while in the background rise the Book-Cadillac Hotel, the Book Building, and the David Stott Building. The circular sign directly behind the clock tower announces People's Outfitting Company.

CADILLAC SQUARE AND BATES, 1932. A bird's-eye view looking along Bates Street reveals a few Detroiters in shirtsleeves and streetcars competing with buses for fares. Occupying the ground floor of the Barlum Tower building on the left is Liesemer's Jewelers and Bostonian Shoes, while on the right is United Shirt Distributors and a coffee shop. One could park in the middle of the street.

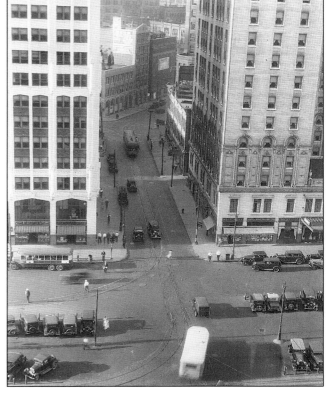

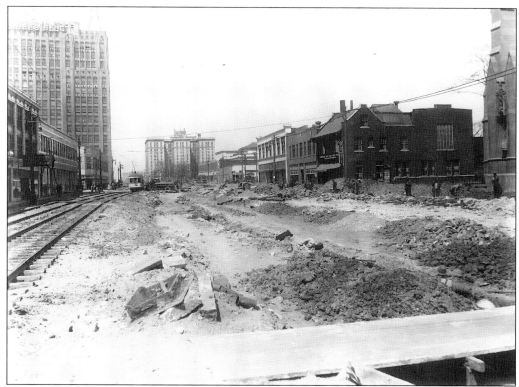

WOODWARD AVENUE AND HANCOCK, LOOKING NORTH, 1930S. A major street renewal is underway as Woodward Avenue is widened in the Hancock area to make room for more traffic. It seems that the only way to get along on this stretch of road was by streetcar while the construction was in progress.

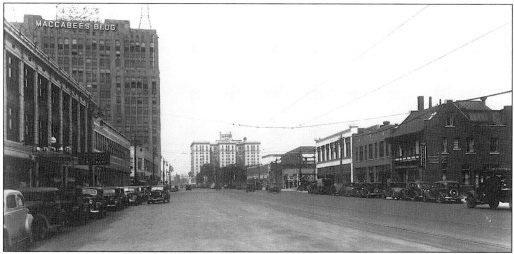

WOODWARD AND HANCOCK, LOOKING NORTH, 1930S. The same scene as above is pictured here after the construction is complete. The Maccabees Building dominates the scene with the visible radio tower of WXYZ, which broadcast the *Lone Ranger* and *Green Hornet* programs to children everywhere. In the middle distance is the Park Sheraton Hotel, while just to its right the Detroit Institute of Arts can be seen.

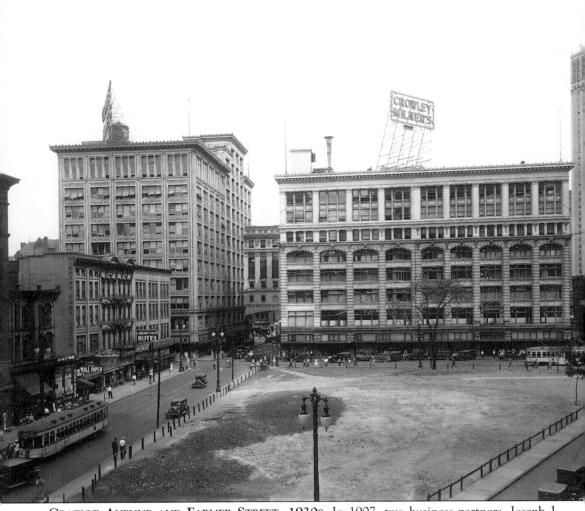

GRATIOT AVENUE AND FARMER STREET, 1930s. In 1907, two business partners, Joseph J. Crowley, son of a Detroit grocer, and William L. Milner, an Ohio entrepreneur, bought a brand new building from a failing specialty shop called Partridge and Blackwell, and they started in business as Crowley, Milner and Company. They made their mark on Detroit by catering to the city's diverse ethnic marketplace. The store offered the latest in "salon" fashions from Paris, exotic gifts imported from Europe, a fine dining room with live music for shoppers, and one of the finest grocery stores in the city located in the basement. By 1917, Crowley, Milner and Company was the largest department store in Michigan. In 1923, Crowley assumed the title of president after Milner's death in an auto accident, and the Crowley family continued to run the business through good times and bad.

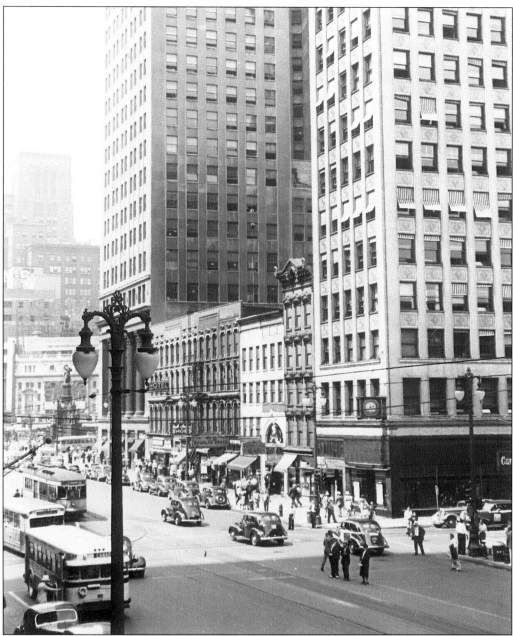

WOODWARD AVENUE, SOUTH OF CAMPUS MARTIUS, 1935. Looking north toward Campus Martius, this is a scene of a thriving business district. The architecture is a mix of newer, taller buildings and structures from just before the turn of the century. Cunningham's Drug Store occupies the ground floor of the Guarranty Building on the right followed by a saloon, a couple of shoe stores, and the Hotel Metropole. The National Bank Building finishes the block. The Hudson's Building looms in the far left, and one can make out the Soldiers and Sailors Monument beneath it. A man boards a tunnel bus in the left foreground, and the folks standing in the middle of the street are waiting for the streetcar.

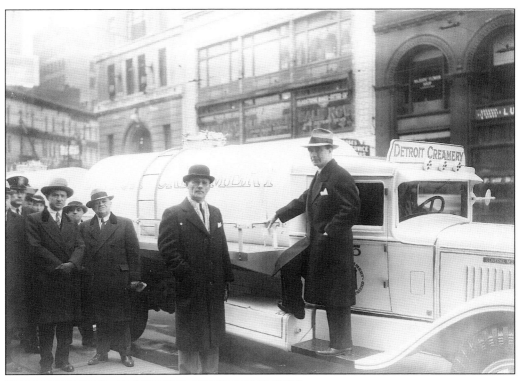

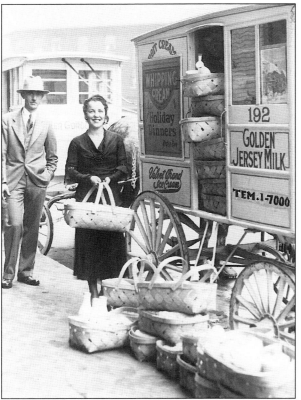

NEW MILK TRUCKS, 1932. Mayor Frank Murphy stands on the running board of a new, specially designed Fruehauf tank trailer. He is with J.H. Watson of the Detroit Creamery Company, to whom 12 of these tankers were delivered. Each tanker could hold 1,250 gallons of milk and were used to bring milk into the city.

CHRISTMAS BASKETS, 1933. The Detroit Creamery Company distributes 1,000 Christmas baskets to those less fortunate Detroiters. An assistant sales manager supervises the loading of the baskets into horse-drawn replica delivery wagons. Prominently displayed are advertising signs depicting the company's various products.

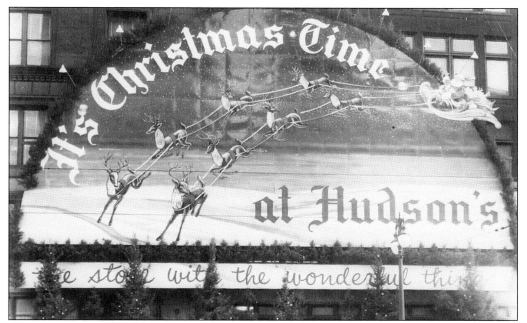

SEASON'S GREETINGS FROM HUDSON'S, 1930S. Detroiters could tell the time of year from the current sign above the Woodward Avenue entrance to the flagship store. This is one sign that kids of all ages waited anxiously for—one that went up just before the big parade. Hudson's—"the store with the wonderful things."

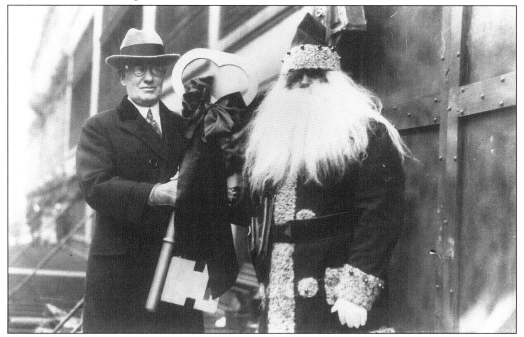

A HERO'S WELCOME, 1930S. City of Detroit Councilman William P. Bradley gives the key to the city to Santa Claus at the conclusion of the Thanksgiving Day Parade festivities. Charles F. Wendel, Hudson's display manager, conceived the idea, and the first parade took place in 1924. It had four bands and ten floats.

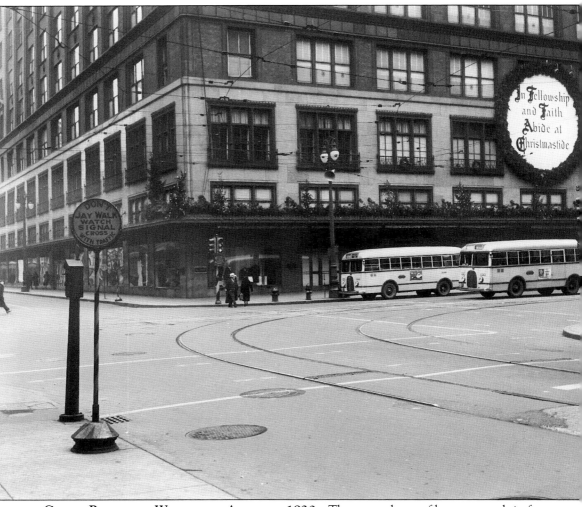

GRAND RIVER AND WOODWARD AVENUES, 1930S. There are plenty of buses to catch in front of Hudson's on the day after Christmas since the downtown area looks pretty much deserted. It wasn't that way just two days before as thousands of Detroiters flocked to this intersection to pick up that last minute gift. It looks as if this Depression-era Christmas was without snow (the streets look completely dry) but not without a meaningful message from the J.L. Hudson Company. Soon Detroit and the nation would burst out of the bad times into a new era of prosperity. A policeman's call box stands next to the "Don't Jay Walk" sign.

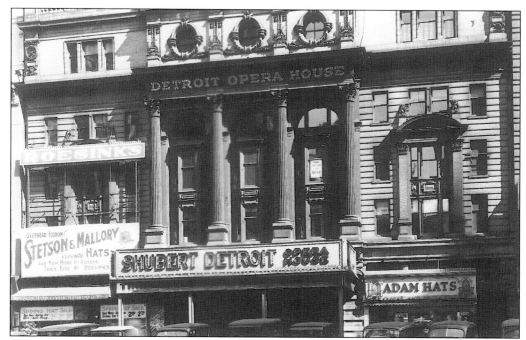

CAMPUS MARTIUS, 1930S. This close-up photograph depicts the Detroit Opera House as it appeared sometime in the spring during the 1930s. The first site of Joseph L. Hudson's store has been taken over by John Roesink, who sold men's hats and other specialty items. Not to be outdone in the "overhead economy" battle is a competitor in the same building, Adam Hats.

CADILLAC SQUARE, 1930S. The Barlum Hotel dominates this side of Cadillac Square, sharing the block with the Detroit Sign Company and Eppinger's Sporting Goods. The parking lot looks like a big-three assembly line. The cars to the right are Checker Cabs, while the others probably belong to office and court employees. The sign beneath the traffic signal admonishes everyone to "be quiet, court zone."

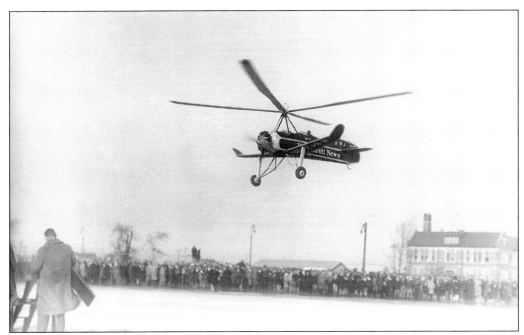

THE *DETROIT NEWS* GYROPLANE, 1931. The *Detroit News* launched its specially designed autogiro on February 15, 1931. It was the first of its kind used for news gathering and aerial photography. The unpowered rotor blades rotated automatically from the wash of the front propeller, giving the craft a great deal of lift and allowing it to take off in a short distance and hover almost motionless.

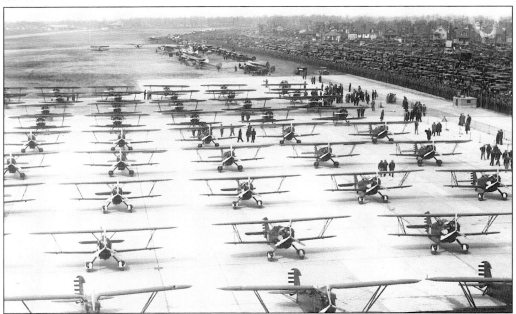

THE ARMY AIR CORPS PAYS A VISIT, 1932. These sleek all-metal biplanes belong to the 32nd Pursuit Squadron stationed at Selfridge Airfield near Mt. Clemens, Michigan. The unit was part of an Army demonstration, or air show, taking place at the Detroit City Airport, where this photo was taken. The planes are Curtis Hawks.

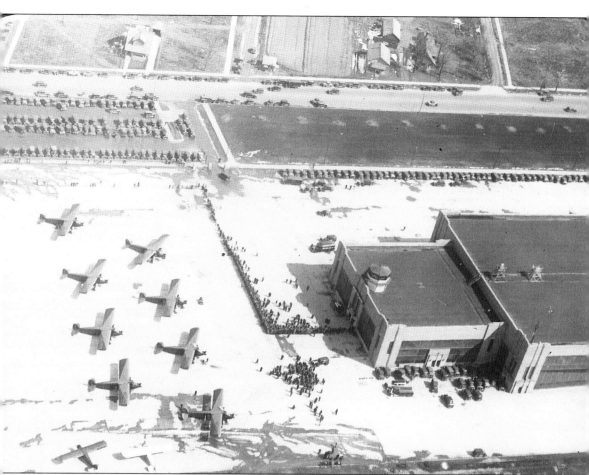

DETROIT CITY AIRPORT, 1930s. People throng the tarmac in front of the Detroit City Airport terminal ready to board one of these eight Ford Tri-Motor airplanes. An hourly plane service from Detroit to Chicago was being implemented. Work began at the Connors Creek site on August 31, 1927, and the airport opened on October 24 of that same year. Pilot Harry Brooks landed a Ford Flivver as the first aircraft, immediately followed by a tri-motored Stout Airlines transport. Brooks flew for Henry Ford, and Mr. Stout designed transport aircraft first for himself, then later for the auto pioneer. The hangar at Detroit City Airport was built in August of 1928.

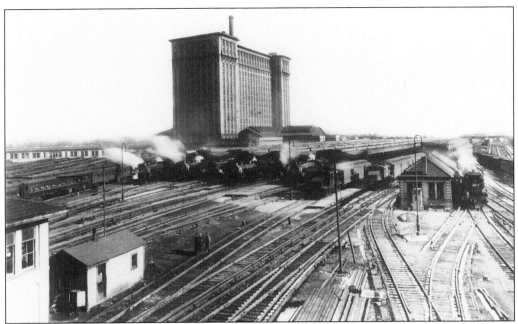

A VERY BUSY YARD, 1930s. The Michigan Central Railroad (MCRR) Depot at Michigan Avenue and Fourteenth Street stands watch over its yards as several locomotives steam up for departure to points west and south from the Motor City. Most of the nation's citizens and freight moved by rail since it was the least expensive and most reliable method of travel.

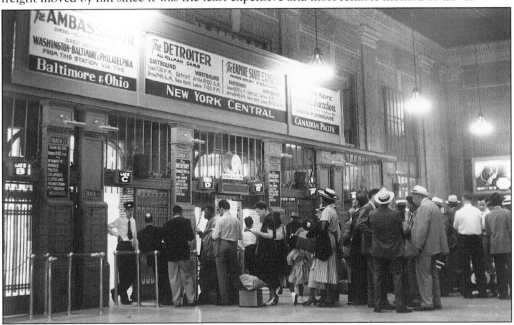

WAITING FOR THE TRAIN, 1930s. These travelers wait patiently for their particular trains to arrive and take them to their destinations. Several railroad companies had a steady business in Detroit as is evident from the sign. The Baltimore & Ohio, New York Central, and Canadian Pacific were three of these, and the New York Central was one of the last lines to leave the metro terminal.

THE INTERIOR OF THE
MICHIGAN CENTRAL RAILROAD
DEPOT, 1930S. Huge windows
provided adequate illumination
inside the depot where these
folks commiserate while
waiting for the train. Passengers
congregate around one of
the snack bars located inside.
The Travelers Aid Society
maintained an office on this side
of the building, and a beautiful
electric chandelier provides
additional light.

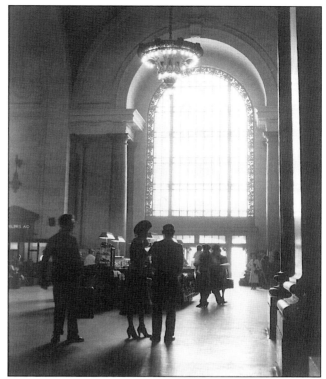

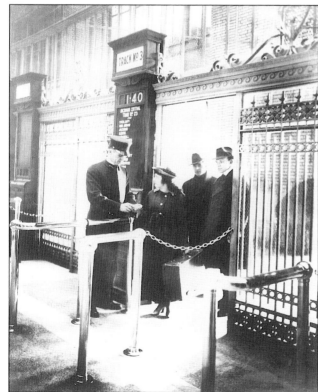

TICKETS, PLEASE, 1930S.
Boarding from track number 3
is one of Michigan Central's
local commuter trains to points
south with stops in Ypsilanti,
Ann Arbor, Jackson, Albion,
and Marshall. This lady appears
to have everything in order,
although the gentlemen behind
her wouldn't agree.

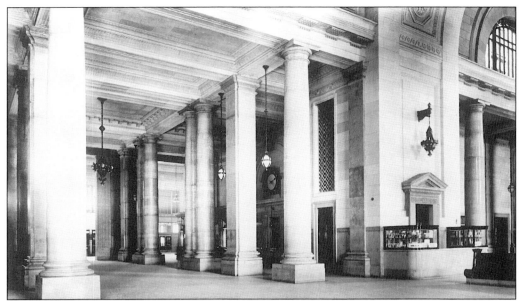

MCRR Depot Interior, 1930s. Built in 1913 by the architectural firm of Warren & Wetmore, who also designed the Grand Central Station in New York City, the Michigan Central Depot was opened for service before its dedication since a fire destroyed the railroad's station at Third and Jefferson. The depot cost $2.5 million to build.

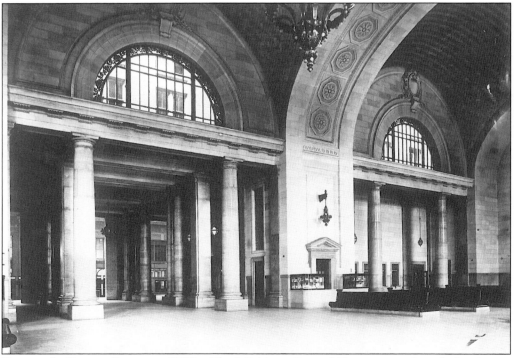

Detroit's Grand Station, 1930s. The Michigan Central Depot was as busy in its time as the Metropolitan Airport is today. In its heyday, as many as 75 trains carrying 5,000 passengers operated in and out of the depot every day. Its Imperial Roman and Renaissance architectural style covers one million square feet.

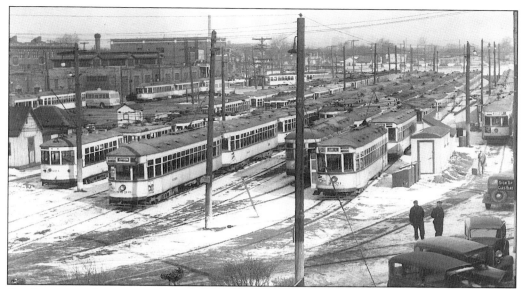

ST. JEAN AND JEFFERSON AVENUE, 1930s. One of the holding yards of the Detroit Street Railway Company was at St. Jean and Jefferson Avenues. Mayor Frank Murphy took over control of the streetcars and actually made them a profitable city business. One could ride the cars for a nickel.

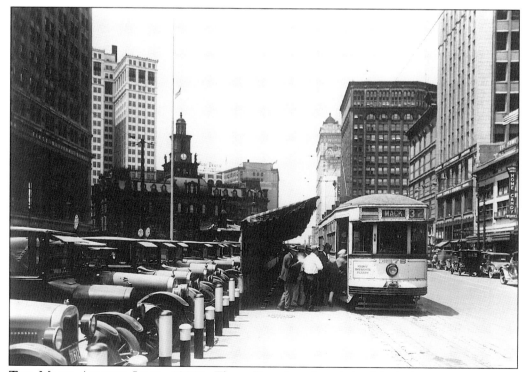

THE MACK AVENUE LINE, 1930s. These Detroiters board the Mack Avenue streetcar at Campus Martius in the early summer. The streetcar company provided awnings at the stops for relief from the summer sun. Since the Home Candy Works was just across the street, your chocolate wouldn't melt as fast.

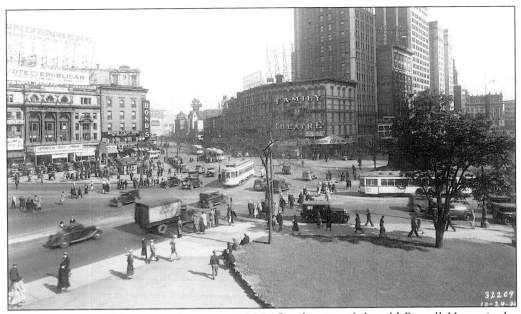

WOODWARD AND MICHIGAN AVENUES, 1934. On the site of the old Russell House is the Family Theater, an early movie house showing continuous talking pictures from 9 a.m. to 11 p.m. for 20¢. Campus Martius is busy on this fall day, and the Republican Party election campaign is underway, calling for votes for "The Party of Human Liberty."

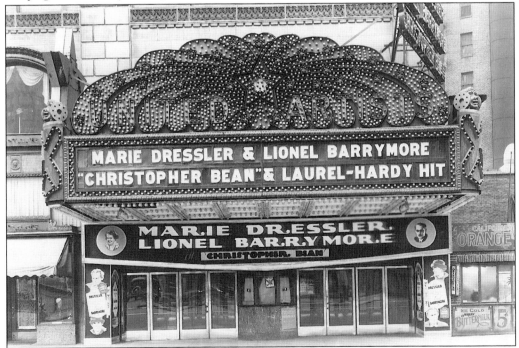

BAGLEY AVENUE AND GRAND CIRCUS PARK, 1930S. Marie Dressler and Lionel Barrymore have top billing in the movie *Christopher Bean* at the United Artists Theater. For the admission price, movie-goers also got to see a Laurel and Hardy short. Just next door, one could quench one's thirst with a glass of California Orange Drink or Jersey Buttermilk for a nickel.

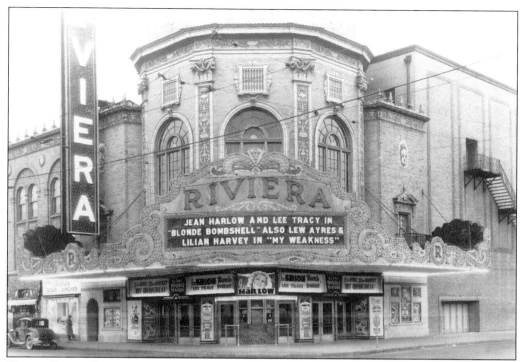

GRAND RIVER AVENUE AND JOY ROAD, 1930S. The Grand Riviera rivaled the Fox Theater in opulence and patron comfort. At the Riviera, movie-goers were treated to a giant double feature and this week could see one of Hollywood's sex goddesses, Jean Harlow, in *Blonde Bombshell*. The ever-present soda shop is right next door.

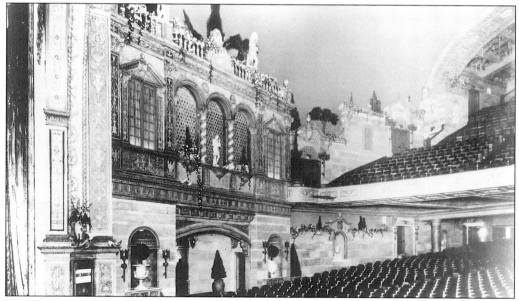

THE GRAND RIVIERA, 1930S. The décor that transformed a theater into a movie palace is evident in this interior photograph of the Grand Riviera taken from the stage. Live trees and plants, ornate facades, and lots of marble statuary make up the opulence of the movie house. Nothing was too grand for Hollywood, even the organ loft.

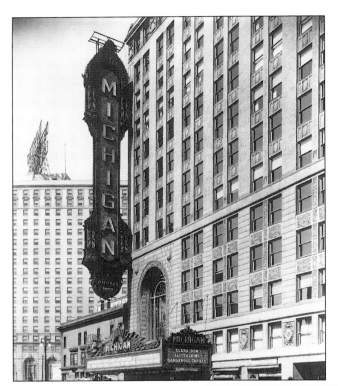

BAGLEY AND CASS AVENUES, 1930s. Another of the city's landmarks was the Michigan Theater, owned at this time by the Publicx Theater group. One of America's sweethearts, Clara Bow, stars with Richard Arlen in *Dangerous Curves*, another "talking" picture. Also on the bill was Buddy Rogers in *River of Romance*. Scheduled to appear was the Michigan Symphony Orchestra.

THE MICHIGAN THEATER, 1930s. The great lobby of the Michigan Theater transports patrons to another world full of climbing pillars and mirrored walls ascending five stories to the domed ceiling. A combination of extravagance and lightness, the Michigan was, in one reviewer's opinion, "beyond the human dreams of loveliness." The theater seated 4,038 patrons.

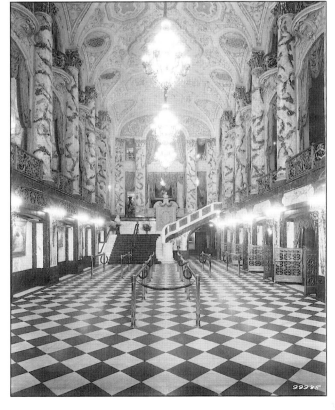

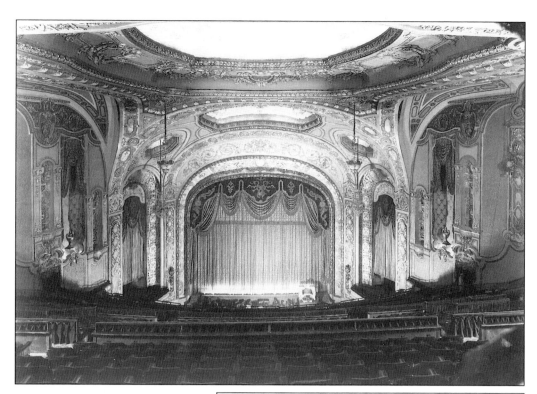

THE MICHIGAN THEATER, 1930S. Suitable for movies and live performances, this view of the theater from the balcony shows the heavy millwork on the walls and ceiling, expressing the grandeur of the movie experience. The velvet brocade curtain is raised, showing more of the stage, and the orchestra pit is just visible below.

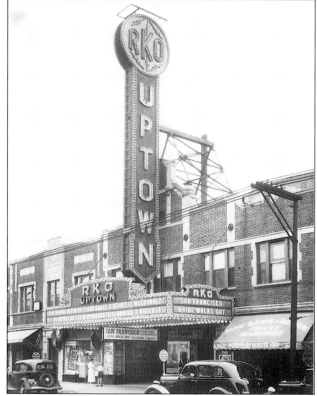

MACK AVENUE AND WOODWARD, 1936. One of the smaller theaters in town was the RKO Uptown, which serviced movie-goers living north of the downtown area. The movie selection wasn't of any less quality as Clark Gable and Jeanette MacDonald starred in *San Francisco* along with Barbara Stanwyck in *The Bride Walks Out*.

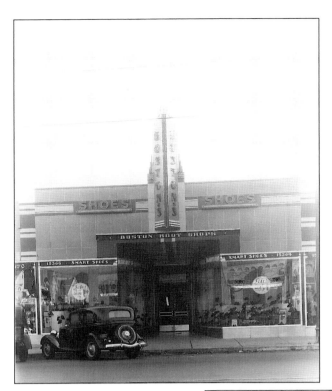

LIVERNOIS AND FENKEL AVENUES, 1935. Symbolic of the art deco style in architecture is the signage of the Boston Boot Shop at 15366 Livernois Avenue. Here, one could buy a pair of dress shoes for $1.98 or a pair of oxfords on sale for $1.68. There were several Boston Boot Shops in the metropolitan area.

WOODWARD AVENUE NEAR GRAND RIVER, 1930S. A longtime fixture on Woodward Avenue in Detroit was the Grinnel Brothers music house, which sold Steinway pianos, other musical instruments, and sheet music. Right alongside is Tuttle and Clark, a "departmentalized" specialty store and Himelhoch Brothers, a clothing retailer.

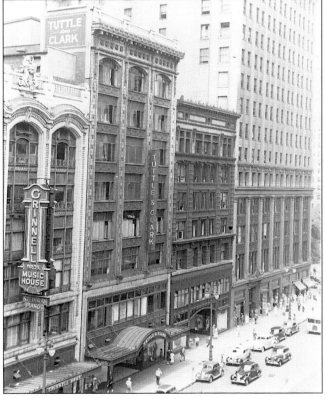

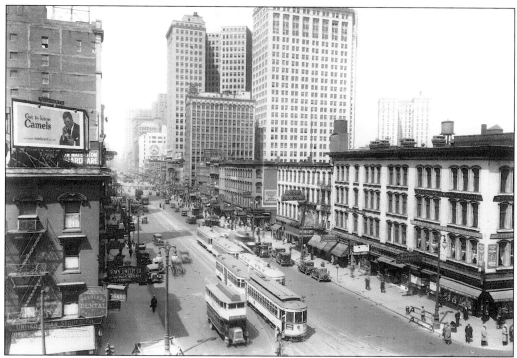

WOODWARD AVENUE, 1934. Looking north from West Alexandrine, the scene is one of a thriving metropolis. On the left is a United Cigar Store with a Peerless Dentist Parlor upstairs, the Crown Jewelry Company, and the Mortgage and Bond Building. On the right is the Empire Dancing School, the Standard Trade School, the Avenue Burlesque, and the Hotel Oxford.

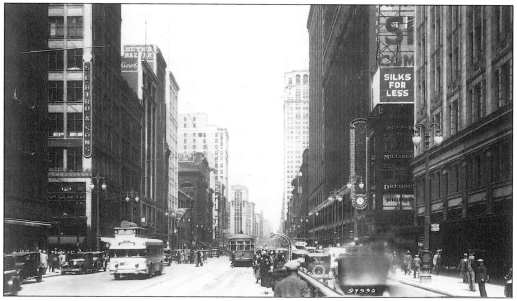

WOODWARD AVENUE AND STATE STREET, 1930s. A street-level shot looking north shows the streetcar stop in front of Hudson's and the National Silk Company, while across the street is the S.L. Bird & Sons clothier, Heyn's Bazaar, and Kresge's. Toward the middle distance are Fyfe's Shoes and the State Theater.

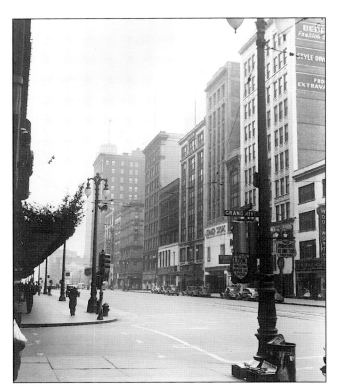

WOODWARD AND GRAND RIVER AVENUES, 1936. "Look Before You Cross" admonishes the corner sign although it looks to be near the end of the day here. On the extreme right we can just see the F.W. Woolworth's store, followed by Burtis Shoes and the Lerner Shops. There is still a mixture of old and new architecture along this section of Woodward.

CADILLAC SQUARE AND WOODWARD AVENUE, 1930s. There are no shoppers out on this rainy morning, and the Penobscot Building stands a proud, silent watch over city hall. In this study of contrasts, city hall looks dark and foreboding and absolutely Victorian, while the Penobscot and the Dime Bank Building represent the brightness of the future.

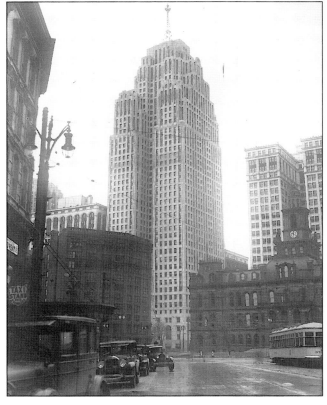

WOODWARD AVENUE, 1939.
The west side of the avenue from State Street to Grand River shows off part of the heart of the retail district. Two five and dime competitors occupy opposite ends of the block with Kresge's and Woolworth's vying for business. In between are the clothiers Klines, Lerner, Burtis, and Bedell.

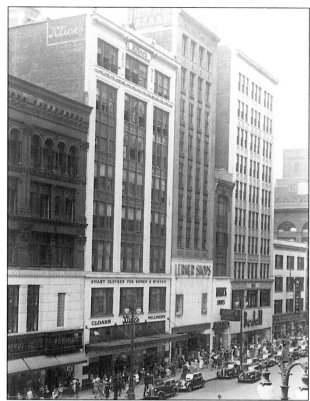

GRAND RIVER AVENUE, 1938.
Rush hour traffic along Grand River in early spring includes a collection of late-model and older automobiles heading toward downtown. An assortment of hotels occupies this section of Grand River. One could stay at the Belmont Hotel for $1 per day with free parking. One of "Detroit's finest" directs traffic at the lower right.

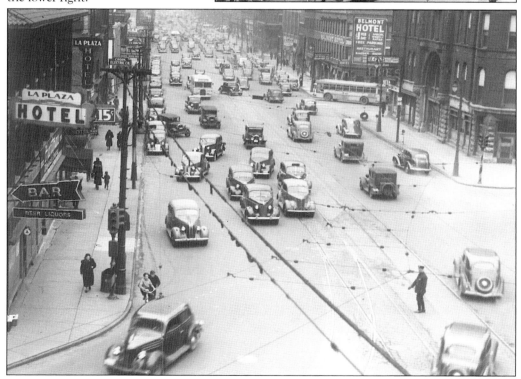

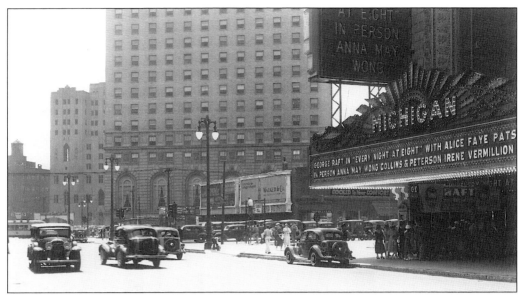

BAGLEY AND CASS AVENUES, 1930S. Movie-goers line up at the Michigan Theater to see George Raft and Alice Faye in *Every Night at Eight*, as well as a personal appearance by Anna May Wong. The overhead sign has changed a bit but the theater's marquee has not. The theater was also "cooled for your comfort."

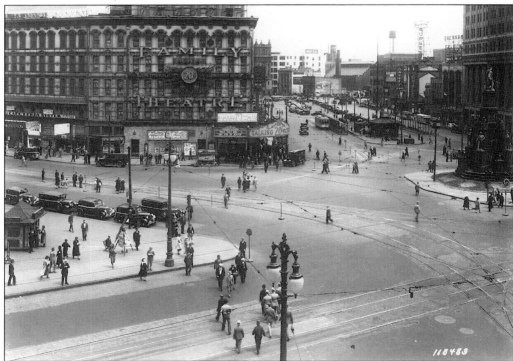

CAMPUS MARTIUS, LATE 1930S. The Soldier's and Sailor's Monument stills stands in memory of Civil War veterans. Next to the Family Theater was Hannon's Cafeteria, a system restaurant that specialized in one-cent, two-cent, and three-cent orders. Behind the monument along Cadillac Square is the Gayety Burlesque, and in the lower left is an information booth.

WOODWARD AVENUE, LOOKING SOUTH, 1938. St. John's Episcopal Church stands majestically in this shot of Woodward Avenue. A mixture of businesses and hotels run along this section with the occasional church spire in between. Jack Benny was playing at the Fox Theater, and just above the church, the Gem Theater, set off by the cinema sign, can be seen.

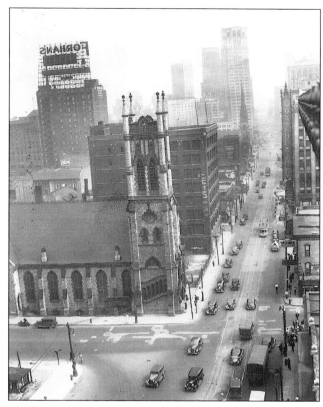

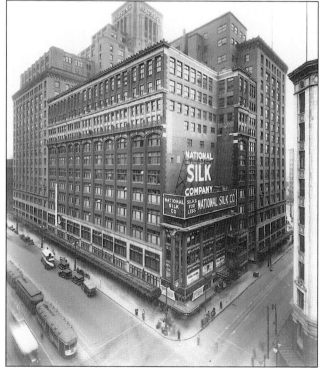

WOODWARD AND GRAND RIVER AVENUES, 1930s. Before the entire block belonged to the J.L. Hudson Company, several other retailers occupied the space. One such organization was Sallan Incorporated, a retail jewelry store. More prominent at this spot is the upper-floor occupant, the National Silk Company, sellers of dresses and hosiery.

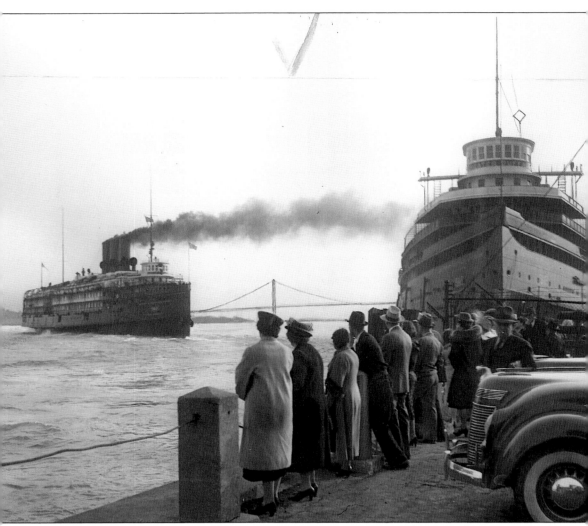

THE DETROIT RIVER AT THE FOOT OF THIRD STREET, 1939. The *City of Detroit III* backs away from the dock as the Detroit & Cleveland Steam Navigation Company inaugurates its service from Detroit to Buffalo, New York. On this maiden trip, the steamer was carrying a special group of Dodge car dealers. The Ambassador Bridge spans the river in the background. For centuries, the Detroit River has been a source of commerce and tourism for the City of Detroit. Excursion steamers as well as freight carriers have made the city prosperous and helped open the area to the rest of the traveling world. River and rail transportation remained the fastest modes of travel well into the 1950s.

Two

THE 1940s

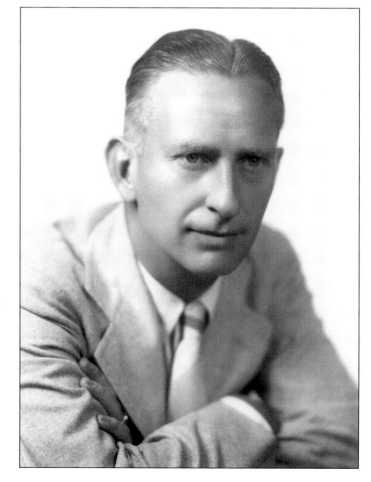

EDWARD J. JEFFRIES JR., MAYOR OF DETROIT, 1940–1948. Born in Detroit, Edward J. Jeffries Jr. attended Northwestern High School and graduated from the University of Michigan with a law degree in 1923. His father, once a judge of Recorders Court, urged his son to take a factory job so he could learn the problems of workingmen first hand. Jeffries did just that on the line at the Ford Rouge plant. Jeffries emerged from that experience with strong pro-labor and pro-union sympathies. Because of these sympathies, as chief executive of Detroit, he rarely fired anyone. He was called "the greatest civil mechanic" in Detroit history because of his thorough knowledge of how and why city government worked.

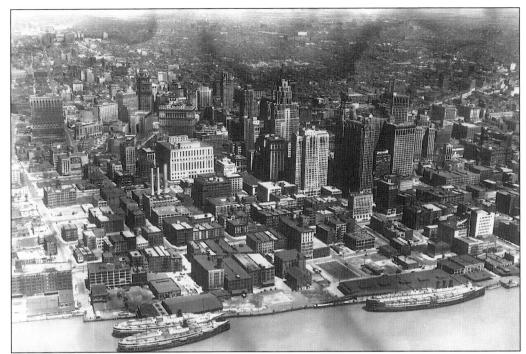

THE DETROIT SKYLINE, 1940s. The Detroit & Cleveland Steam Navigation Company's boat *City of Detroit III* (right) and *Eastern States* (left) wait at their berths for their next excursion as the city awakens to a new decade. This section of the riverfront, with its warehouse district, has changed completely, but several skyscrapers are still in place.

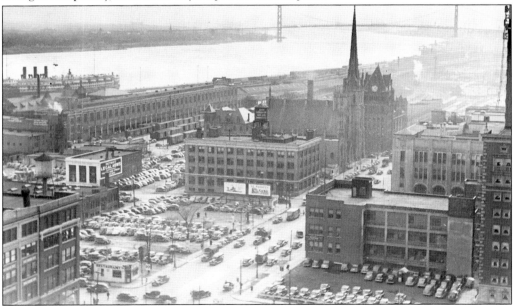

THE DETROIT RIVER, 1940. The Ambassador Bridge spans the river in this view of the riverfront from atop the *Detroit Free Press* Building. John Borman & Son Printers stands next to the Fort Street Presbyterian Church, and in the background is the Michigan Central Railroad yard. The white-fronted building (middle left) houses the *Detroit Legal News*.

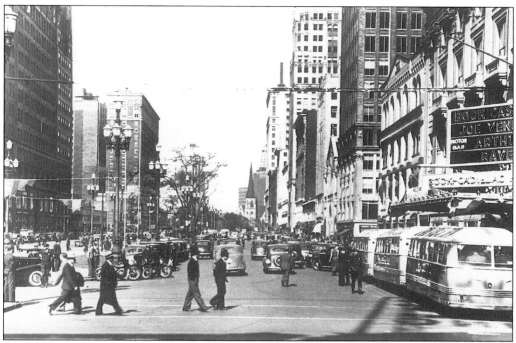

WASHINGTON BOULEVARD, 1940. This scene, facing north, reveals a futuristic-looking set of sightseeing or excursion vehicles parked in front of the Book-Cadillac Hotel. The welcome sign is being displayed for a convention, and there are at least five of "Detroit's finest" present, including two motorcycle cops.

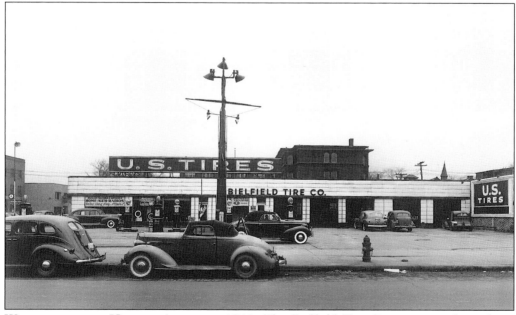

WOODWARD AND HARPER AVENUES, 1940. The Bielfield Tire Company stands ready to service the automotive needs of the Motor City. They sold Sunoco gasoline and U.S. Tires. A customer could also buy a Philco, Motorola, or Detrola home or auto radio—on the company's Easy Pay-Plan, of course.

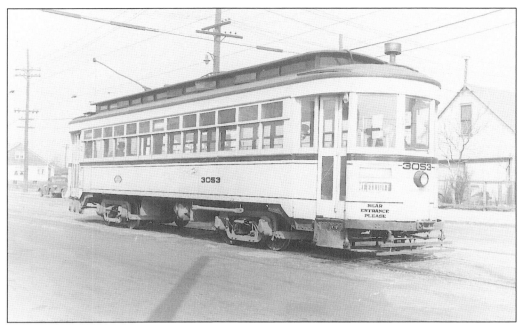

RAPID TRANSIT, 1940. This Detroit Street Railway car used on the Mt. Elliot route is typical of streetcars in use from the teens through the 1950s. This one was built by the Kuhlman Car Company in 1917 and was 46 feet long, 8 feet wide, and had seating for 46 passengers.

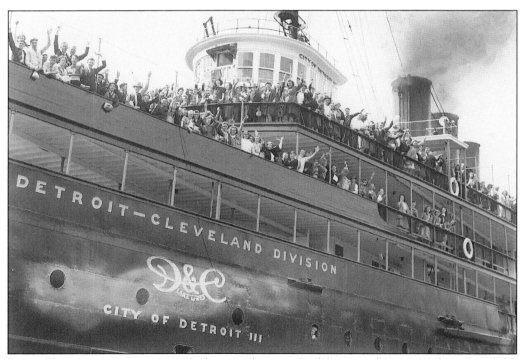

RIVER TRANSPORTATION, 1940. A close-up photograph of the *City of Detroit III* shows hundreds of Michigan school children on a visit to Detroit. This group of residents from Shiawassee County came to the city by rail and took an excursion on the steamer as part of their school outing.

SECOND BOULEVARD AND WEST BALTIMORE, 1940S. The Fisher Building looms over Second Boulevard as the Dexter and Second Avenue buses proceed along their routes to the river. Also on this route is the *Old Frankenmuth* beer truck. One could park all day for 20¢ across from the 6 and 8 Pontiac dealership.

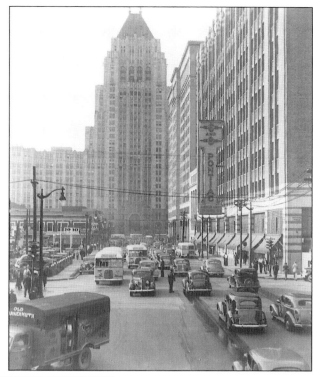

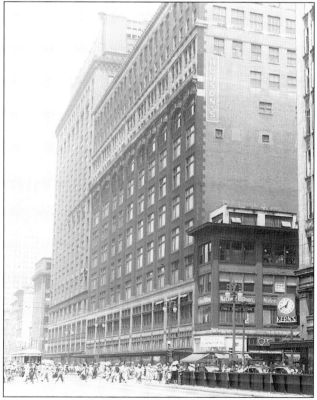

WOODWARD AND GRATIOT AVENUES, 1940. Downtown shoppers abound in front of the Hudson's Building during the last pre-war year. The National Silk Company has gone elsewhere and was replaced by a public beauty shop and Mary Lee Candies. The Kern's clock says that it is 12:40 in the afternoon.

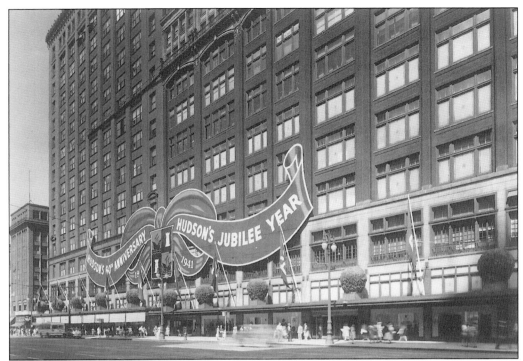

WOODWARD AND GRATIOT AVENUES, 1941. The J.L. Hudson Company celebrates its 60th anniversary with a huge placard on its flagship store. Founded by Joseph L. Hudson in 1881, the company grew to be one of the largest department stores in the Midwest. By summer's end, war clouds would loom on the horizon and by the end of this anniversary year the country would be engaged in conflict.

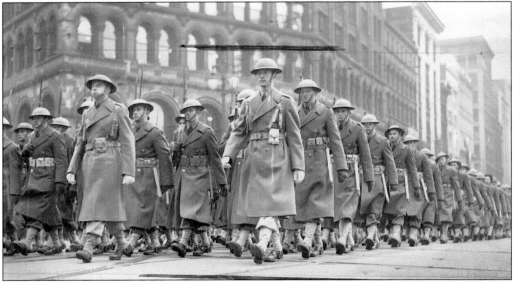

WOODWARD AVENUE, 1941. A somber-looking group of trainees from Fort Custer, Michigan, take time out from their training to participate in an Armistice Day parade up Woodward Avenue. Smartly turned out in the appropriate winter issue uniforms, these troops are led by their officers and sergeants past the Majestic Building.

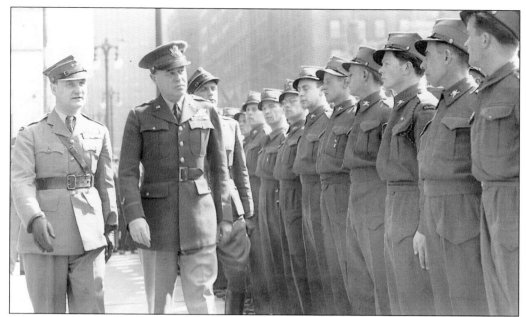

CAMPUS MARTIUS, 1941. These Polish non-commissioned officers have completed their training and are preparing to return to the European theater. Prior to their departure, they form ranks in front of the Federal Building for inspection by their captain, George Ciepielowski and Major General C.R. Powell, district commander. They are all veterans of the battle of Dunkirk where they fought with the British.

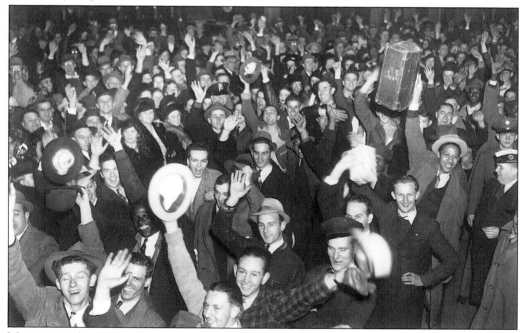

MICHIGAN AVENUE AND FOURTEENTH STREET, 1942. The first batch of Detroit draft volunteers wave enthusiastically to the camera as they await departure from the Michigan Central Railroad Depot to their training camps. This mixed batch of All-Americans range in age from 18 to about 35, and the group includes some African Americans.

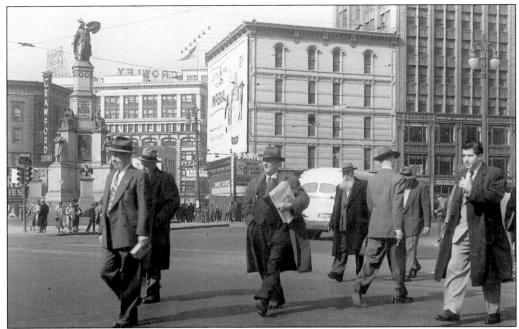

CAMPUS MARTIUS, 1942. These Detroiters will soon be the ones guarding the home front, as all appear to be beyond draft age. In the background (from left to right) is the Soldiers and Sailors Monument, a tribute to the state's manpower contribution in an earlier war; the Family Theater; and the Cadillac Square Building.

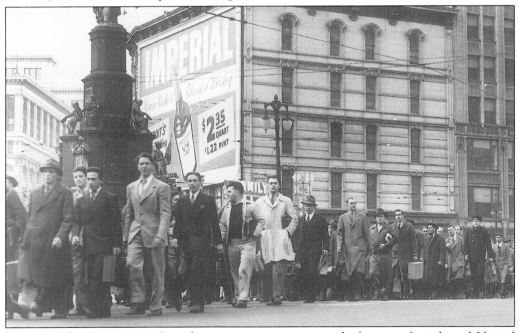

CADILLAC SQUARE, 1942. Past the same street corner march these newly inducted United States Navy recruits in the early spring of 1942. Most of these men will be shipped off to the Great Lakes Naval Training Station just north of Chicago, Illinois, and will finish off their careers somewhere in the Pacific theater.

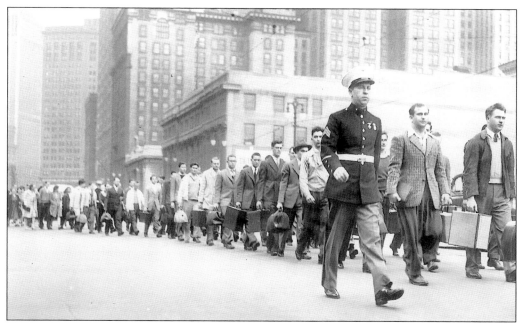

LAFAYETTE BOULEVARD, 1942. Not to be outdone by the United States Navy, these men are being marched down to the railroad station on their way to becoming United States Marines. As this recruiting sergeant steps out proudly, his flock follows as best they can. They will be taught how to walk properly in San Diego, California, as Marine Corps boots.

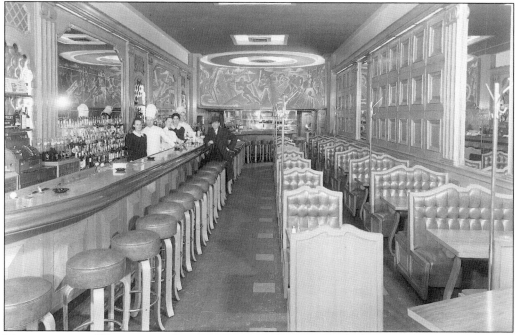

MICHIGAN AND WOODWARD AVENUES, 1942. The Brass Rail Theater Bar stands ready and waiting for its patrons to return. Long a fixture near the theater district of Detroit, the Brass Rail, located at 116 Michigan Avenue, offered patrons a relaxing atmosphere in which to reflect on the show or movie just seen.

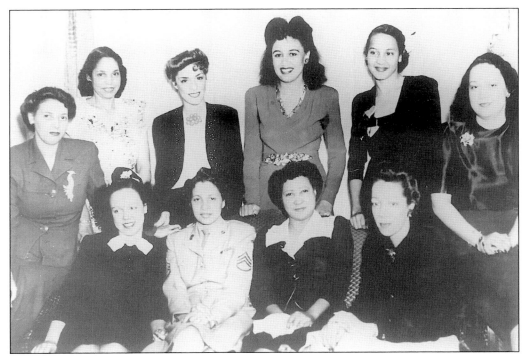

ON THE HOME FRONT, 1940s. These ladies take time out for a group photo with one of their own, who is home on a furlough, in uniform. Detroiters such as these volunteered with organizations such as the United Service Organization (USO) to provide entertainment and refreshments for the men and women in uniform.

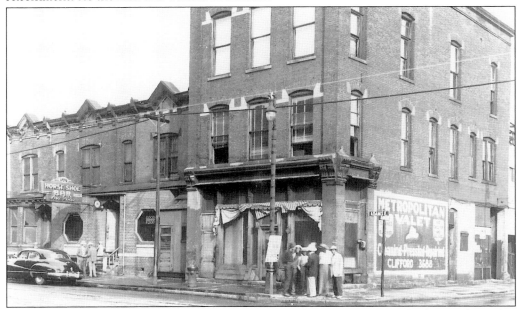

EAST ADAMS AND ST. ANTOINE, 1940s. The Horseshoe Bar stands in the heart of Paradise Valley, an African-American community that occupied the near-east side of Detroit. A group of men gather on the corner to exchange news and information and to plot out the coming night's agenda of entertainment.

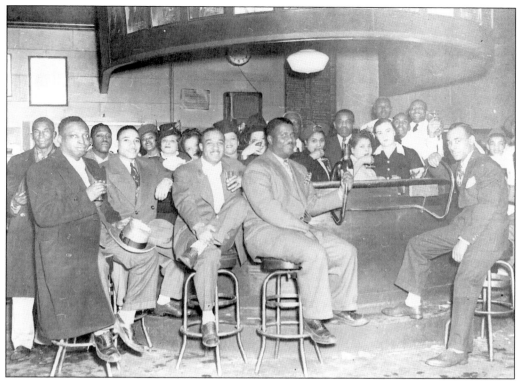

PARADISE VALLEY, 1940s. The Horseshoe Bar patrons relax after a hard week's work in Detroit as the city gears up to supply the armed forces with material and equipment. People migrated to the city from the Deep South to work in the war industry as the city transforms itself into the "Arsenal of Democracy."

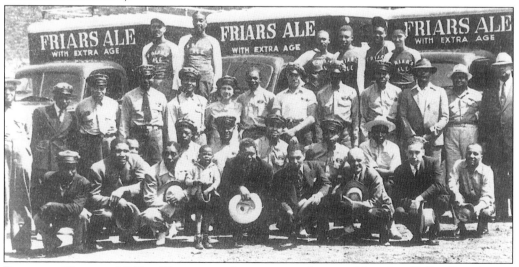

PARADISE VALLEY, 1940s. The men and women employees of Paradise Valley Distributors pose for a company photograph in front of three delivery trucks advertising *Friars Ale*. This wholly owned African-American business was quite successful in the city. Pictured here are the drivers, secretaries, and salesmen of the company along with the company-sponsored baseball team.

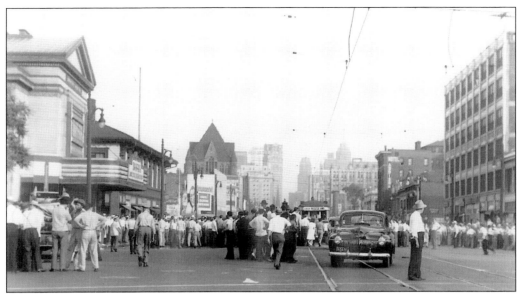

WOODWARD AVENUE, JUNE 1943. Since the start of WW II, more than 50,000 Southern African Americans and a half-million Southern whites migrated to the "Arsenal of Democracy" seeking employment. Racial tension followed. Over 100,000 Detroiters gathered on Belle Isle on Sunday, June 20 to escape the heat and humidity of the city. Small fights and larger assaults soon broke out. Police were able to quell the melee without a single gunshot, but rumors were rife of racial violence.

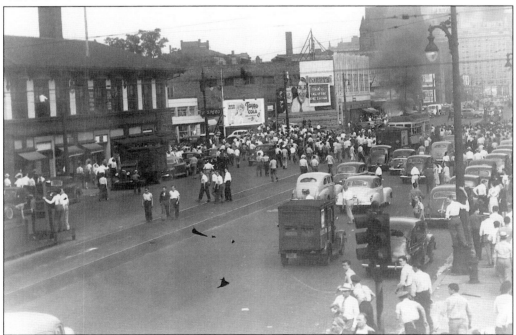

WOODWARD AVENUE, JUNE 21, 1943. Stories of racial violence spread to all sections of the city. Real violence soon broke out in Paradise Valley and overflowed its boundaries. Rumors of rape on Belle Isle enraged the white crowds forming along Woodward, who attacked all the African Americans caught outside of Paradise Valley.

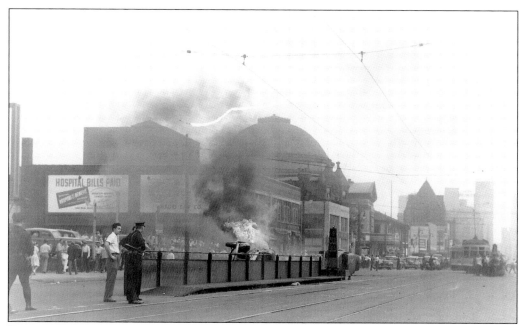

THE VIOLENCE CONTINUES, 1943. The angry crowd stopped, overturned, and burned automobiles driven by African Americans. Fresh rumors kept refueling the frenzy, and the police were slowly losing control. It was agreed that the city needed the help of federal troops, but no one in government could make the timely decision. Military police units were put on alert but were forbidden to enter the city without prior approval.

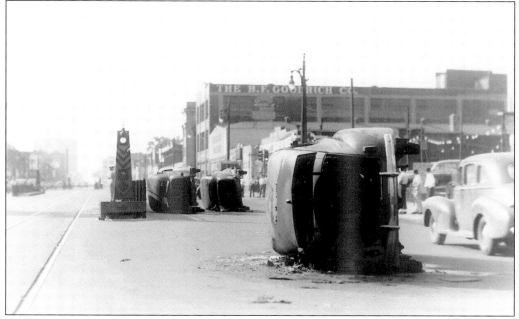

IN THE AFTERMATH OF VIOLENCE, 1943. Federal troops were finally ordered into Detroit to stop the rioting but not until 21 hours after the government had first planned to use them. It was during this delay that most of the riot toll was recorded: 34 dead, over 70 injured, $2 million in property losses, and one million man-hours lost in war production.

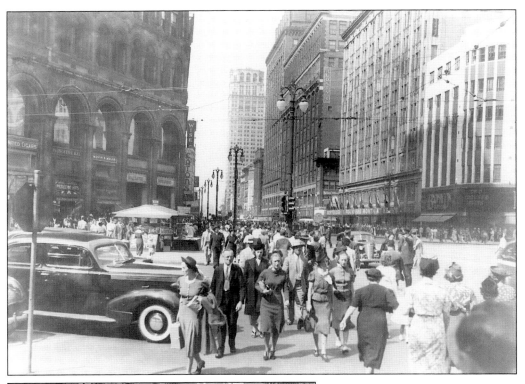

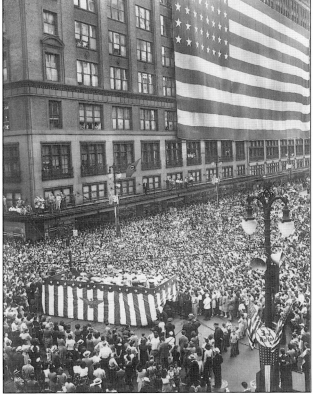

WOODWARD AVENUE AT MICHIGAN, FALL 1943. The marquee on Kern's proclaims "September is Founders Month at Kerns," and Bond Clothiers is selling two trouser suits while shoppers pursue the best deals. The newsstand in front of the Majestic Building does a brisk business in magazines and out-of-town newspapers.

WOODWARD AVENUE, 1943. The world's largest flag is prominently displayed on the Hudson's Building, and the avenue is jam packed as Detroiters gather to hear patriotic speeches given in support of the Third War Loan drive. The speakers stand has its complement of real-live heroes, as furloughed veterans were required to participate.

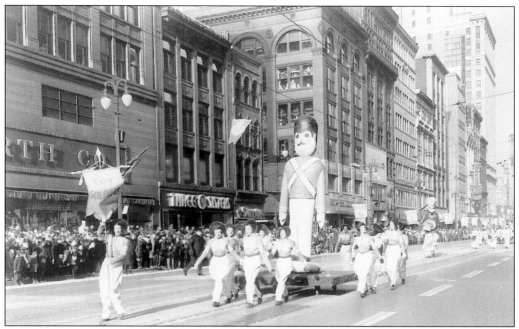

WOODWARD AVENUE, 1943. The annual J.L. Hudson Company Thanksgiving Day Parade goes on as part of the war effort on the home front. This hand-pulled float depicts an inflatable toy soldier guided along by female volunteers dressed in the appropriate costumes. Following behind is a very tall Uncle Sam.

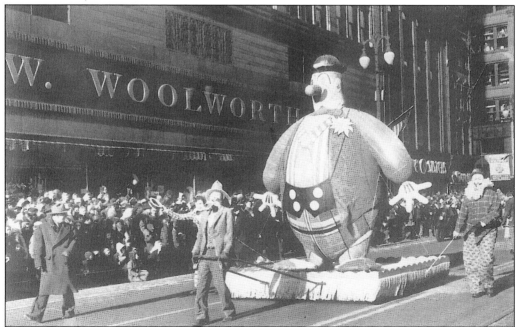

JUST CLOWNIN' AROUND, 1943. Another float makes its way past the Woolworth store on Woodward Avenue. These floats are definitely a far cry from today's motorized versions, but with the war on, it fit the bill. Detroiters were able to set aside their troubles at least for a while as the Christmas season opened.

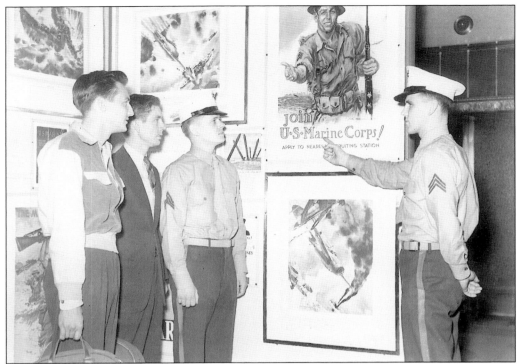

THE FEW, THE PROUD . . . 1940S. More than 1,000 war posters are on display at the General Motors Building, and these two Marine Corps sergeants take their duty seriously in the Corps section of the show. The two civilians look as though they are packed and ready to answer their country's call.

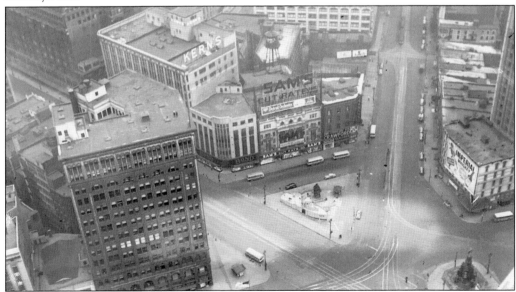

CAMPUS MARTIUS, 1943. This view looking down on Campus Martius shows a deserted city. Detroit was practicing blackouts at this time, and this is the result fifteen minutes after the air raid sirens went off in a daylight alert. The streets were emptied, and stores and office buildings were crowded with people taking shelter form the air raid.

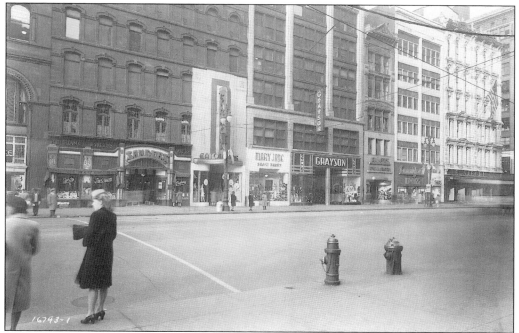

WOODWARD AVENUE, 1940S. A portion of the retail district along Woodward Avenue shows some landmark shops in this post-war photograph. Eaton's had women's dresses for $2. Mary Jane shoes followed, then Grayson's coats and gowns, Allen's millinery, Cunningham's drugstore, Sherman's shoes, and the shops were anchored on the corner by B. Siegel's. And who wouldn't have time for a Sander's sundae?

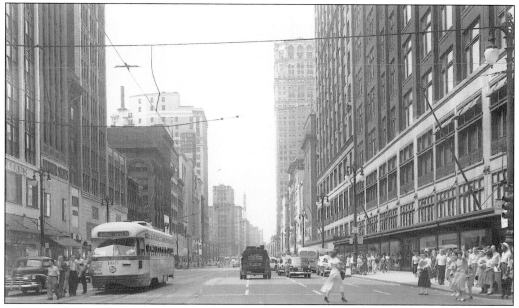

WOODWARD AVENUE, LOOKING NORTH, 1948. The southbound Woodward streetcar stops to let riders off in front of Kline's clothing store. The crowd of people on the right seem to be watching the woman crossing against the light. The Fox Theater has yet another style of sign, this one shaped like a rocket.

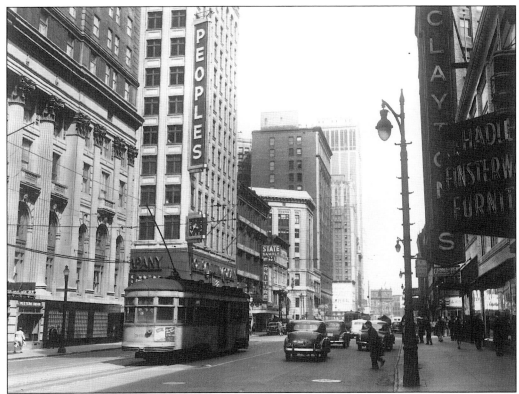

MICHIGAN AVENUE, LATE 1940S. Checker cabs compete with streetcars for fares along Michigan Avenue in the view just west of Woodward. People's Outfitting Company gave other stores stiff competition from this corner for a good many years. This is also a block of furniture stores, at least one on each side of the street.

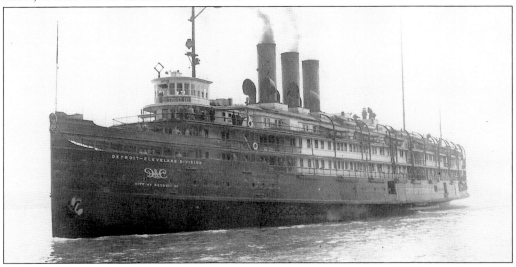

BETTER LATE THAN NEVER, 1947. The *City of Detroit III*, a Detroit & Cleveland Steam Navigation Company boat, finally pulls up to the dock at the foot of Shelby Street 12 hours late on its run from Buffalo to Detroit. The steamer was feared lost to some freakish accident, but was late because of a severe storm on Lake Erie.

GRAND RIVER AVENUE AND BEVERLY COURT, 1940S. The Grande Ballroom, opened in 1928, boasted one of the largest polished hardwood dance floors in the Detroit area. The advent of radio and television would begin the ballroom's decline, but one could listen to the big bands of the day and have a chance to meet someone of the opposite sex.

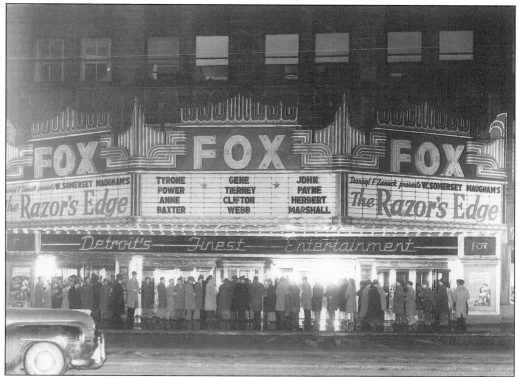

WOODWARD AVENUE, 1948. Movie-goers line up at the box office window to see an evening showing of Darrel F. Zanuck's production of *The Razor's Edge*, starring Tyrone Power and Gene Tierney. The Fox was the last moving picture palace to be built in downtown Detroit and had a seating capacity of 5,041 people.

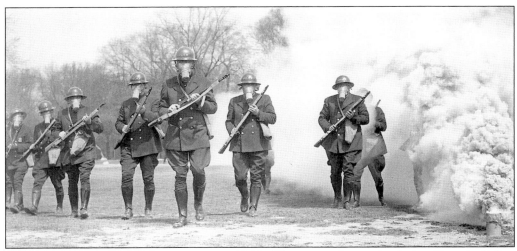

THE DETROIT POLICE DEPARTMENT, 1949. This special squad of the Detroit Police Department go through their paces in practice at controlling civil disturbances. In a scenario where tear gas is involved, these troopers are equipped with the latest in gas masks and doughboy-type steel helmets. Their riding breeches and boots make them part of the mounted division.

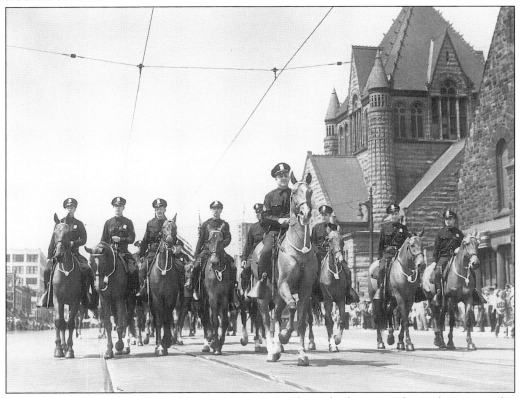

THE MOUNTED DIVISION ON PARADE, 1949. Looking far better without the gas masks, members of the Detroit Police Department's Mounted Division pass in review during a parade in downtown Detroit. Formed in 1893, the Mounted Division continues to be one of the finest departments of the "boys in blue."

WOODWARD AVENUE AND CONGRESS, LATE 1940s. A bird's-eye view of Woodward looking toward the river reveals more buses than streetcars on this stretch, although folks are waiting in the middle of the avenue. Just in front of the Bob-Lo ticket office is the Vernor's bottling plant, advertising Vernor's Ginger Ale.

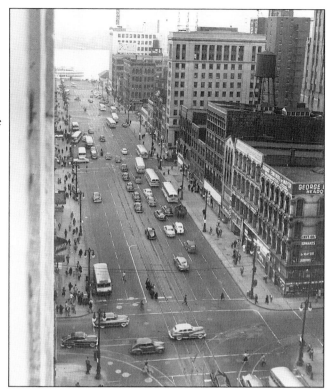

WOODWARD AVENUE AND GRAND CIRCUS PARK, 1949. The Central Methodist Episcopal Church stands open to worship in this pastoral scene of Woodward Avenue. People line up to board the Harper bus while others just stroll down the avenue. Street signs extol people to "give once to the United Foundation."

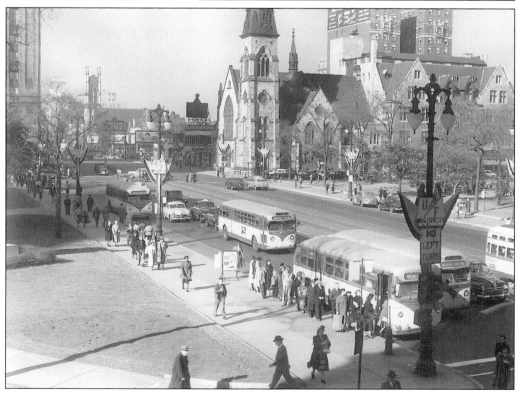

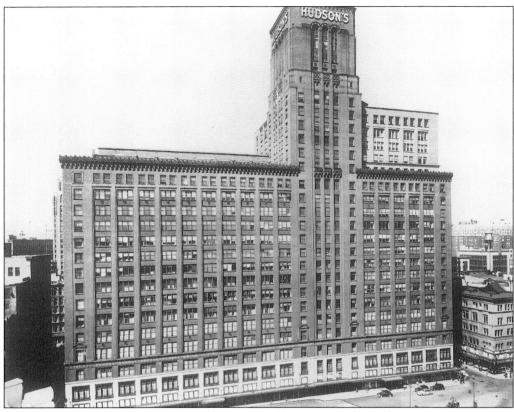

THE FLAGSHIP STORE, 1949. Instantly recognizable at just a glance from any direction, the Hudson's Building was the place to visit and shop for generations of, not only Detroiters, but folks from the suburbs as well. Especially memorable are visits to see Santa Claus and the huge toy department during the holiday season.

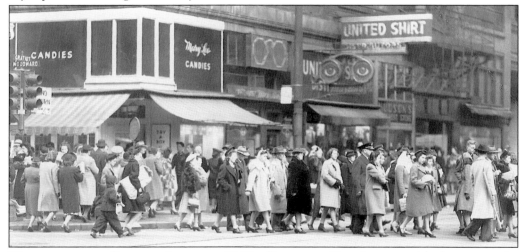

WOODWARD AND GRATIOT AVENUES, 1940S. Downtown Detroit teems with shoppers at the start of the Christmas season in this view from the late 1940s. It looks as though there was very little, if any, snow to brighten up the holiday, but that doesn't seem to bother these stalwarts. Just next to United Shirt is the Hudson's discount store.

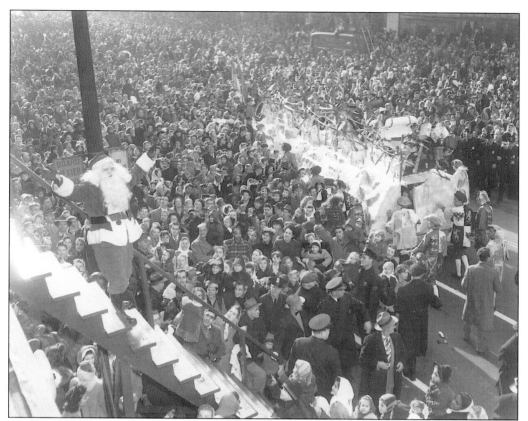

THE END OF THE ROUTE, 1948. Santa Claus waves to the Woodward Avenue crowd as he makes his way up the stairs and into J.L. Hudson's at the conclusion of another successful Thanksgiving Day Parade. Someone is peeking out from inside his float while Santa's helpers, wearing official City of Detroit livery, move Santa's sleigh towards the reindeer parking zone.

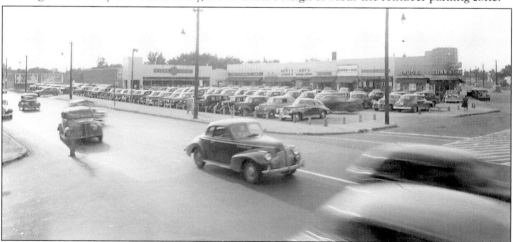

EAST SEVEN MILE ROAD AND CONANT, 1949. The tremendous growth of the residential areas of the city demanded more convenient shopping. Here is one of the early strip malls on the northeast side of town. Anchored on each end by an A&P and a Cunningham's Drug Store, there is also Kresge's, two shoe stores, and a dry cleaners.

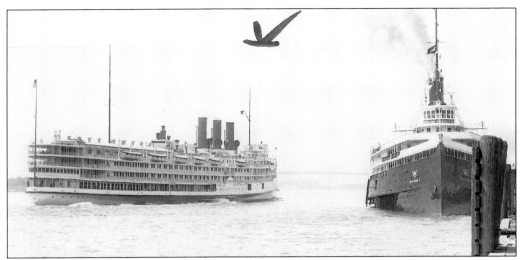

DETROIT RIVER TRANSPORTATION, 1949. As a sign of the changing times and for the first time in the history of the Detroit & Cleveland Steam Navigation Company, its traditionally dark green boats have been painted white. On the left, the *Greater Detroit*, dressed in her new colors, glides down the river past the stalwart *City of Detroit III* in the company's old colors.

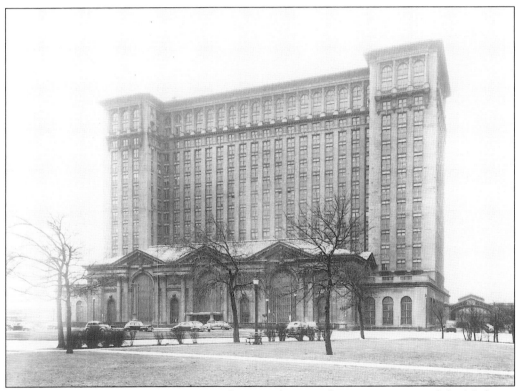

RAILROAD TRANSPORTATION, 1949. Looking southeast at the main entrance of the Michigan Central Railroad Station, one finds it pretty much business as usual. Transportation by rail was still fast and economical, with the trains running frequently and on time. The station still serviced as many as four major railroad lines as passenger trains and many others that moved freight.

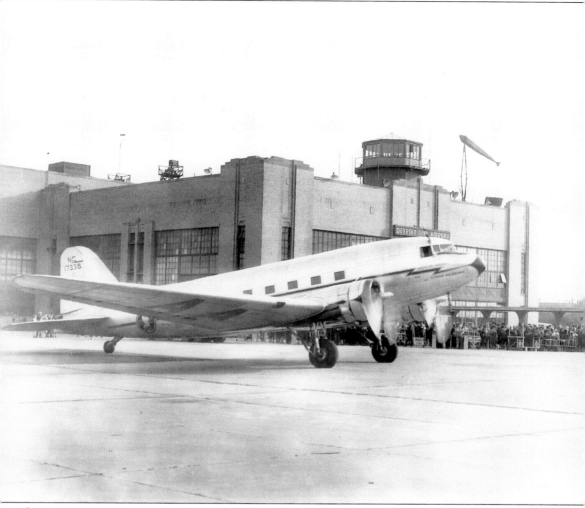

GRATIOT AVENUE AND CONNOR, 1949. This American Airlines DC-3 stands ready to move out from the main terminal at Detroit City Airport. A transport aircraft developed during the late 1930s, the DC-3 became a mainstay of both the Army Air Corps and United States Navy during WW II, delivering supplies and personnel to the four corners of the globe. Returned to civilian service, the planes made excellent passenger carriers and, dressed in the colors of the different airlines, helped to make air transportation safe, convenient, and popular. Although soon supplanted by larger, faster four-engine craft, the DC-3 continued to serve well into the 1960s.

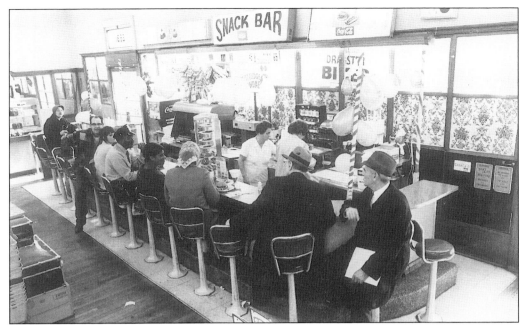

FAST FOOD, 1949. The snack bar at Kresge's dime store is well visited in this shot—even the beat cop has time for a quick bite. Serving sandwiches, soup, and hamburgers, as well as desserts, a paying customer could still eat cheaply on a shopping trip. Remember the cone-shaped paper cup with the metal holder?

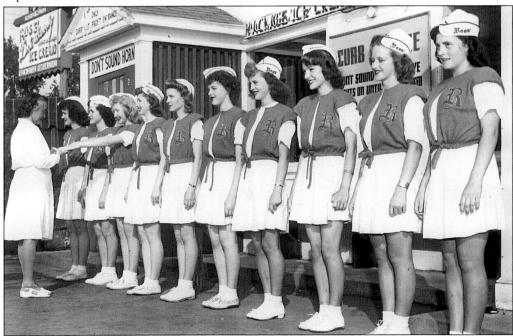

THE SHAPE OF THINGS TO COME, 1949. Carhops line up for inspection prior to starting their shift at Ross' Deli Dainty. Every girl had to have clean hands, proper fingernails, and the uniform of the day. Ross' offered curb service "de-luxe" and carry out but absolutely no dine-in facilities. This was back when a malted was a malted.

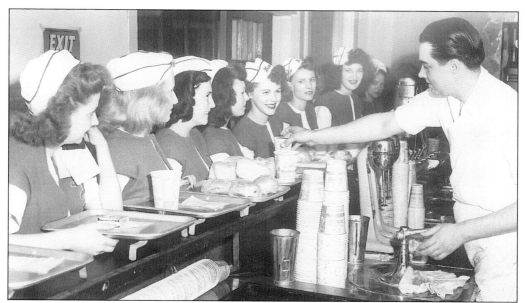

FAST FOOD AT ROSS', 1949. Carhops line up to get their orders from the owner/chief cook, and they evidently provided service with a smile. It looks like the main fare today was hamburgers with a Coke or two thrown in. The hop on the extreme left has a pack of Camel cigarettes as part of her order.

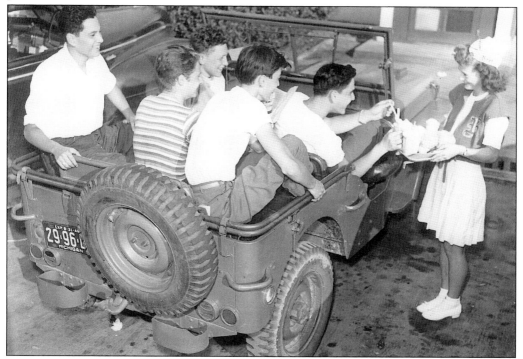

ARMY SURPLUS HELP, 1949. Service comes with a smile as these five gentlemen get their order to go at Ross'. The men's transportation has been provided courtesy of Uncle Sam as they are crammed into a surplus general purpose vehicle or "jeep." But what are they going to hook their order tray on?

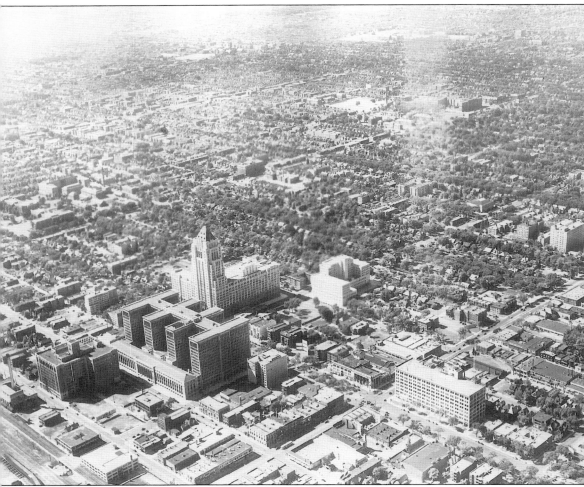

THE VIEW OVER NORTHWEST DETROIT, 1949. This aerial shot of the northern section of the city shows the area as it was prior to the express highway. Prominent in the photograph are the Fisher and General Motors Buildings, two of Detroit's more recognizable structures. Both buildings, erected during the 1920s, remain architectural jewels and anchor the northern part of the city's business and cultural life. The GM Building contains 1,800 offices with room for 6,000 tenants. The ground floor had 12 showrooms for automobiles and related products. This area was the Fisher brothers' dream of a "new center" of business and culture for the city of Detroit.

Three

THE 1950s

ALBERT E. COBO, MAYOR OF DETROIT, 1950–1957. Born in Detroit in 1893, Albert Cobo first entered city service from private industry as city treasurer during the Great Depression. In those chaotic financial times, Cobo had the law amended that provided for crushing penalties for those whose taxes were delinquent. He then got the law changed that permitted professional tax title buyers to grab up property on which taxes were not paid. Cobo then secured a legal arrangement by which people in arrears on their taxes could pay them over a period of seven years. His seven-year plan became nationally famous and prevented Detroit from falling into ruin. He was made mayor almost by popular demand and also reelected. During his administration, work began on the construction of the expressway system, the civic center, and the riverfront beautification program. Albert E. Cobo was the first mayor of Detroit to die in office.

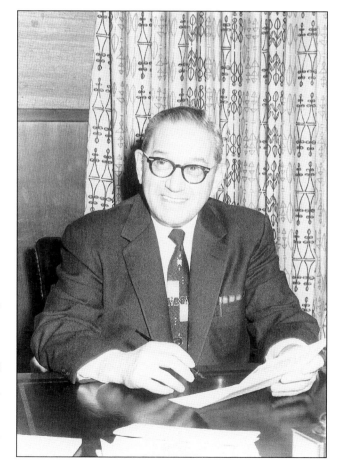

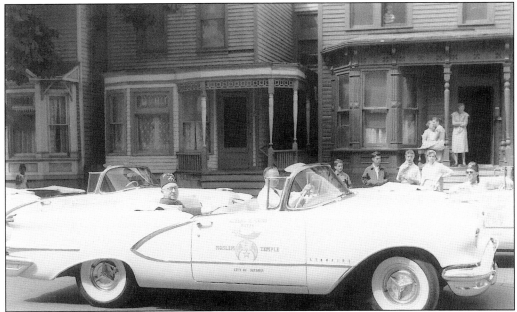

A MAYORAL PARADE, 1950s. Albert Cobo sits in the back seat of a brand new Starfire in preparation for a Shriners parade. There were few political leaders who were always as close to the people as Cobo was or who knew the people's needs and aspirations better. Cobo was a familiar and welcome figure among all the social and national organizations that make up community life.

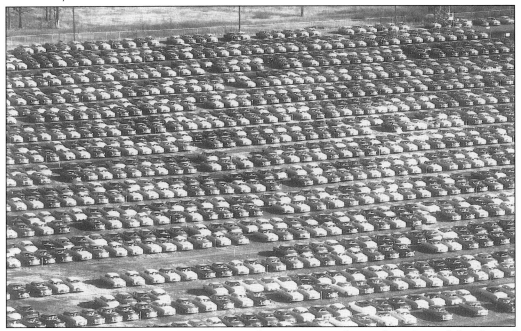

THE MIGHT OF THE MOTOR CITY, 1950. The major manufactured product of the City of Detroit was the automobile as can be seen in this image of a huge lot holding brand new model Packards. Detroit was maintaining its place at the forefront of automobile manufacturing and would do so for another two decades.

WOODWARD AVENUE AND LARNED, 1950. Looking north along Woodward Avenue from Larned reveals a mixture of financial and retail establishments. The Michigan Bank sits next to a Cunningham's Drug Store just before the Campus Martius/Cadillac Square area. There is still a mixture of old and new architecture as well. This is the site of the Russell House, an early Detroit hotel.

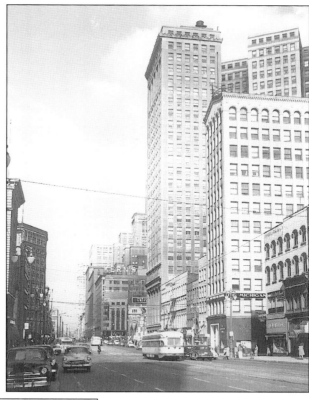

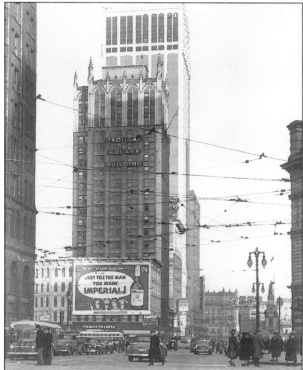

CADILLAC SQUARE AND GRISWOLD, 1950. An eastward view on Cadillac Square from Griswold Street still shows Detroiters awaiting streetcars in the middle of the avenue, even though there are more city buses to be seen. The Barlum Tower rises above the Cadillac Square Building, and in the middle distance is the Lawyers Building. A pint of Hiram Walker's Imperial whiskey would set one back $2.10.

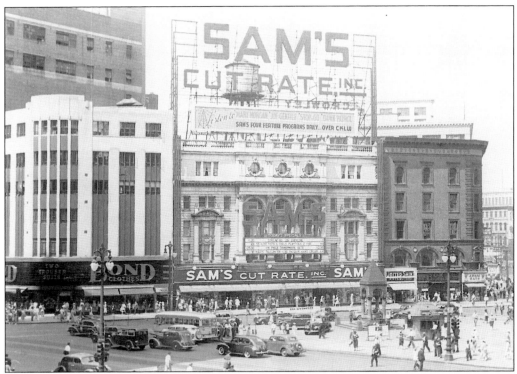

CADILLAC SQUARE, 1950. The old Detroit Opera House now houses Sam's Cut Rate department store, where anyone could go and listen to four radio programs on the CKLW station. That day's store specials included Similac for 62¢, Tots and Girls playtogs for 89¢, and 116-piece dinnerware sets for $12.95. Adam Hats is still on the corner.

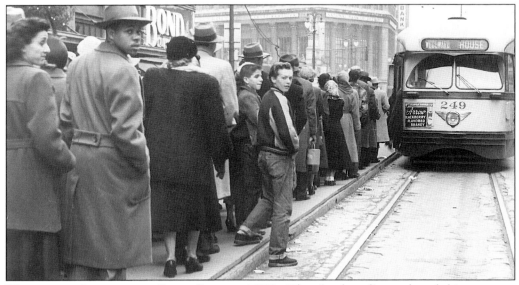

WOODWARD AVENUE AND STATE STREET, 1950s. There's a long line to board this streetcar, and some folks turn to see who is taking their picture. The lady at the extreme left seems to be totally bored with the whole idea. The Detroit Street Railway would soon be on strike, crippling transportation.

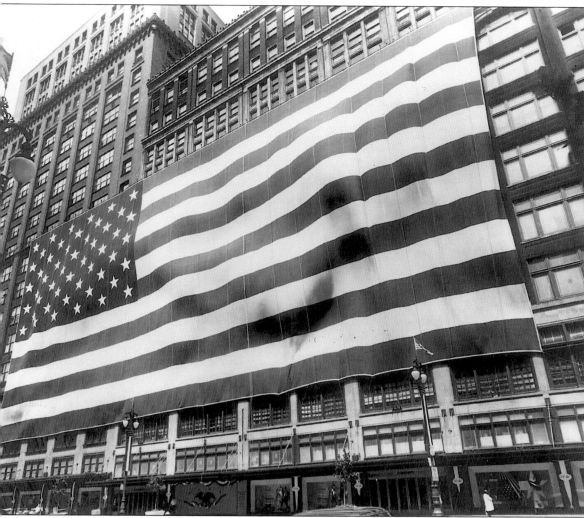

THE WORLD'S LARGEST FLAG, 1950S. The world's largest flag adorns the J.L. Hudson's Building in downtown Detroit. First unfurled on the building on Armistice Day (now Veteran's Day), November 11, 1923, this flag is 90 feet tall and 230 feet long. It weighs 900 pounds and required 8 and one-half miles of thread to stitch it together. There are 840 yards of 42-inch red material, 681 yards of 42-inch white, and 260 yards of 48-inch blue. The material used in this flag would make 517 and one-half flags, each 5 feet by 8 feet large. The Hudson's flag was flown on Veteran's Day, Memorial Day, and on the Fourth of July.

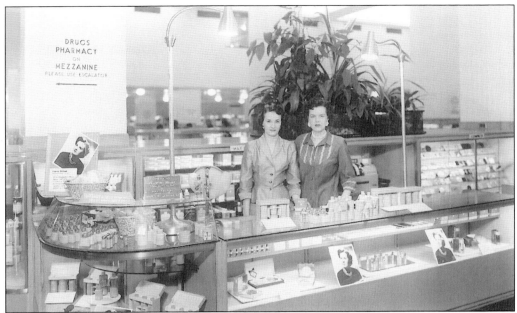

BEAUTY IN A BOTTLE, 1951. The cosmetic counter at Hudson's downtown store featured Mrs. Frances Holland (on the right), a make-up artist and special salon consultant from Max Factor, on that day. She was giving classes in make-up and skin care using Max Factor products. Shoppers were invited to use the escalator to get to the pharmacy.

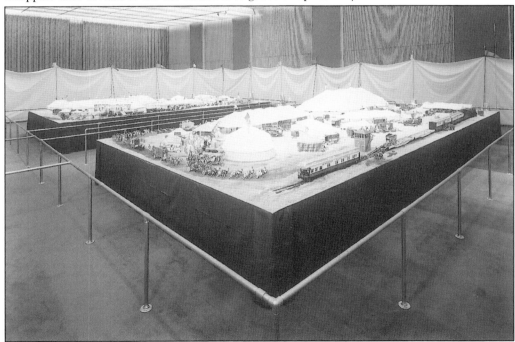

A TABLE-TOP CIRCUS, 1951. One of the pleasures of any trip to Hudson's was to see what new displays were there. These two big display tables depict the Ringling Brothers Circus in miniature. On the near table the train has arrived and is in the process of unloading while the circus parade begins to line up. The far table features the Wild West parade.

72

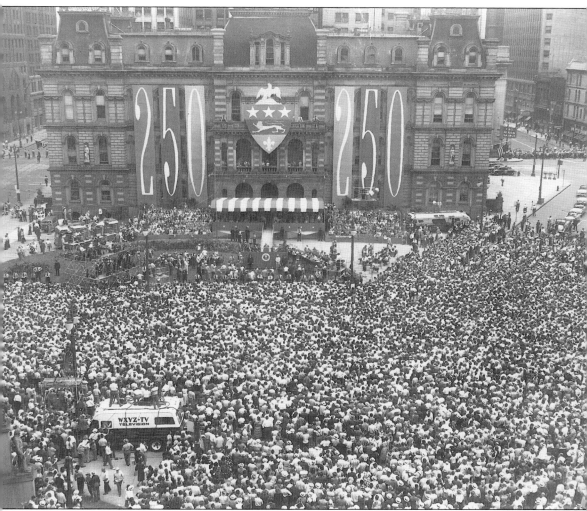

OLD CITY HALL, 1951. A huge crowd gathers in front of city hall to hear Pres. Harry Truman deliver an address to the city on the occasion of its 250th birthday, July 24, 1951. Preparations for the event began over a year before with flyers on Detroit history, tourism, business, and entertainment. The logo for the anniversary depicted a French fleur-de-lis and a British lion surmounted by the American eagle, symbolizing the three governments in control of the city. The citywide celebration lasted all year with different programs, both educational and entertaining, sponsored by civic and cultural organizations, and, of course, there was a parade.

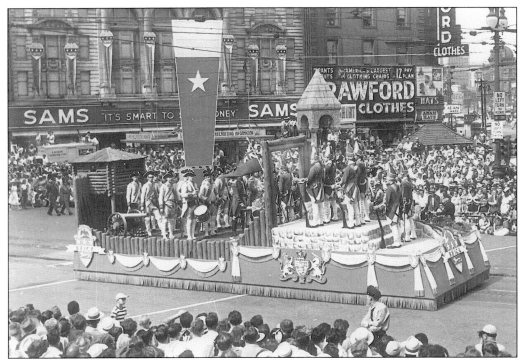

WOODWARD AVENUE, 1951. A huge parade proceeds down Woodward Avenue in July 1951 to celebrate the birthday of Detroit. This particular float, sponsored prominently by Buick, depicts the French surrender of the fort to the British in 1763 at the conclusion of the French and Indian War.

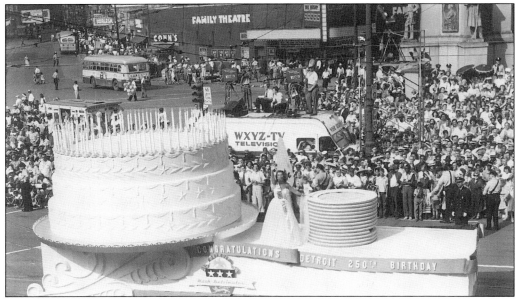

WOODWARD AVENUE, 1951. No birthday party is complete without a cake, and this one looks big enough to feed most of the city. On a float sponsored by the Nash-Kelvinator Company rides Jacque Mercer, Miss America for 1949. I hope that the next float has the ice cream—that would be the ice cream float, right?

WOODWARD AVENUE, 1951. Parking on Woodward was at a premium during this time, especially when city transportation went on strike. Heavy automobile traffic downtown would become a reality soon enough. The signs on the streetlights encourage Detroiters to "Clean Up, Paint Up, Fix Up Your House"—just in time for spring.

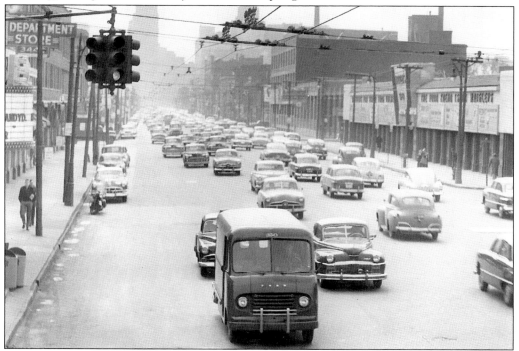

GRAND RIVER AVENUE, 1951. Early morning rush hour along Grand River looking toward the downtown area finds quite a bit of traffic but all apparently moving well. A Hudson's delivery van moves past the Globe Theater on the left. A Wrigley's Super Market is the first building on the right. The Penobscot Building and the Barlum Tower loom in the distance.

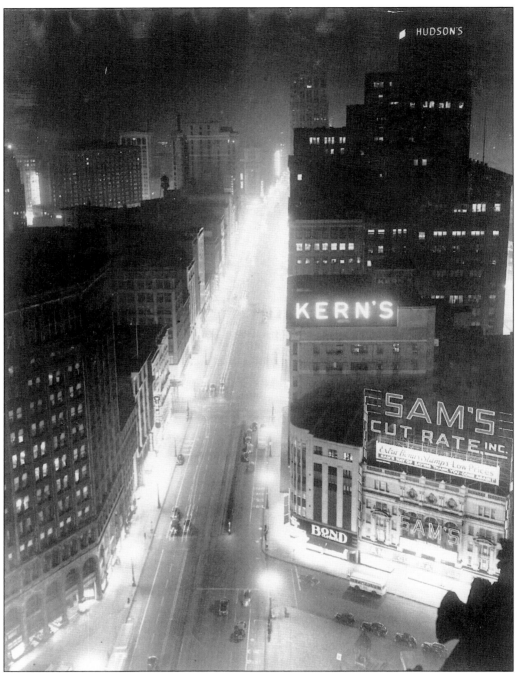

WOODWARD AVENUE AT NIGHT, 1952. The Motor City is ablaze with lights in this nighttime view of northbound Woodward Avenue from the Campus Martius area. The Majestic Building still stands at the extreme left, but there is a more festive air from the retail stores on the right. Sam's Cut Rate offers extra bonus stamps as their way of saying "thank you, come again." Bond Clothes right next door appears more stately, while a bit further up the block, one could not miss Kern's or the Hudson's Buildings. Sam's Cut Rate was the first downtown major retailer to integrate its sales staff.

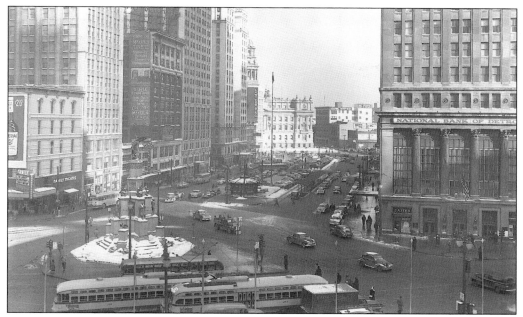

CADILLAC SQUARE, 1952. Snow adorns the tops of cars and the Soldier's and Sailor's Monument in this winter view of old Campus Martius. The Woodward streetcars embellish the foreground of the photo, and as we look east toward Beaubien, we can see the Wayne County Building just behind the Lawyers Building.

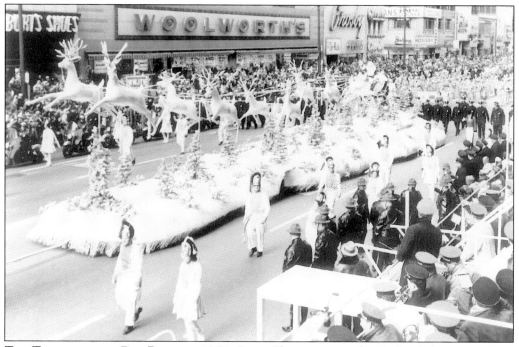

THE THANKSGIVING DAY PARADE, 1952. Santa Claus arrives at the Hudson's downtown store to officially start the holiday shopping season. With as many of "Detroit's finest" around, one wonders if the "old man" was speeding down Woodward Avenue. The stores opposite all seem to have acquired new signs and some new façade work.

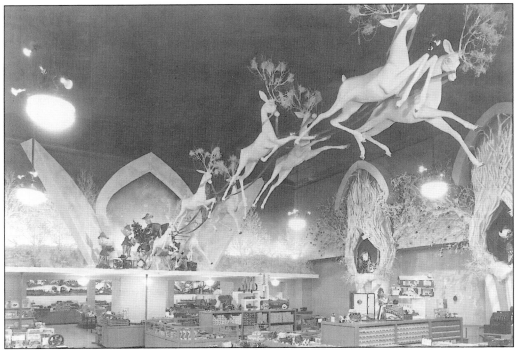

HUDSON'S TOYLAND, 1952. At Hudson's flagship store some remarkably familiar reindeer soar above the toy department, which waits in orderly fashion to fill those wish lists. Santa's elves work out of tree trunks and help to load the sleigh. Tootsietoys fill up the counter on the right while animal toys and picture books take up space on the left.

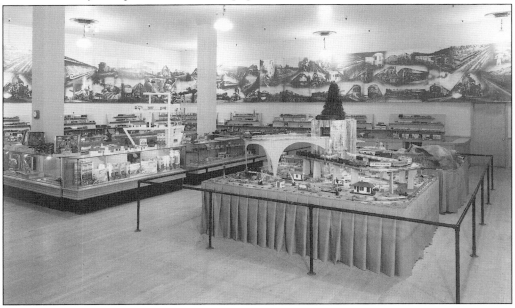

THE MODEL RAILROAD DEPARTMENT, 1952. Every modeler's wish would come true with a visit to this department. Alongside the department's working Lionel railroad layout were all the accessories anyone would need to build their own train set. Assembled buildings, extra track, railroad cars, or a set of Block City blocks were right there ready to go under the tree.

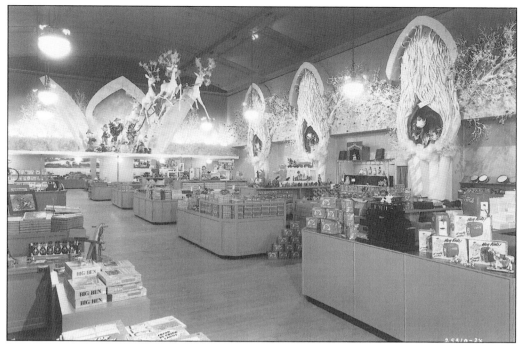

EVERY KID'S DREAM, 1952. A longer view of the toy department shows the enormous selection available to Christmas shoppers. In the middle right are a selection of dolls, toy telephones, and, of course, stuffed animals. On the left are the bicycles, and in the foreground the jigsaw puzzles. On the extreme right is a Coca-Cola dispensing machine that really works!

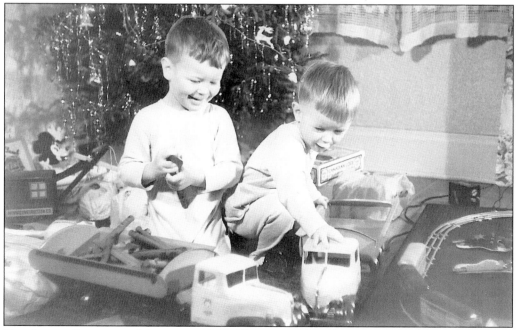

THE JOY OF CHRISTMAS MORNING, 1952. These two fellows have hit the jackpot with enough heavy equipment to rebuild the neighborhood. The electric train set on the right appears to be an "American Flyer" of pre-war vintage, and there is a notable mouse on the left.

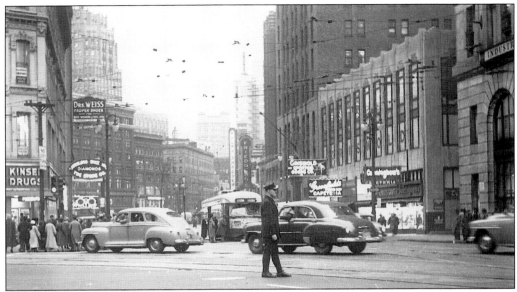

MICHIGAN AVENUE AND GRISWOLD, 1950S. One of Detroit's "boys in blue" bravely directs traffic along Michigan Avenue in this late afternoon photo. The good Doctors Weiss sold proper shoes, The Stone Company sold diamonds, and, on the corner, Kinsel Drugs sold everything else. One could get a quick bite to eat at either Greenfield's or Cunningham's cafeteria.

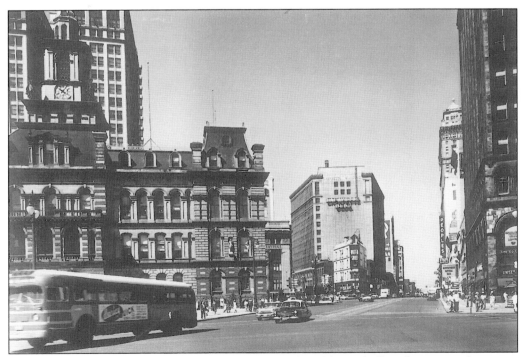

MICHIGAN AND WOODWARD AVENUES, 1950S. The old city hall still commands respect among her more modern neighbors while the Majestic Building stands close by as city hall's only contemporary. The Lafayette Building dominates the intersection in the middle distance. Right around the corner from the Majestic is a new bank called Manufacturers National Bank.

WOODWARD AVENUE AND GRAND RIVER, 1953. Robinson's of Michigan anchors the corner at Woodward and Grand River in an area of clothing shops and shoe stores. A *Detroit Times* delivery truck fills the newspaper dispenser in front of the building. Robinson's offered three ways to pay for goods: cash, layaway, or budget account.

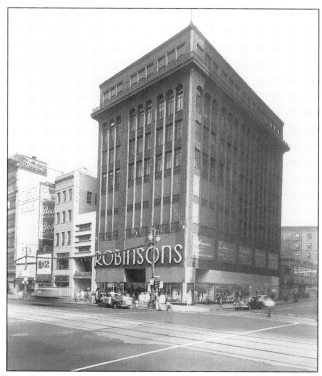

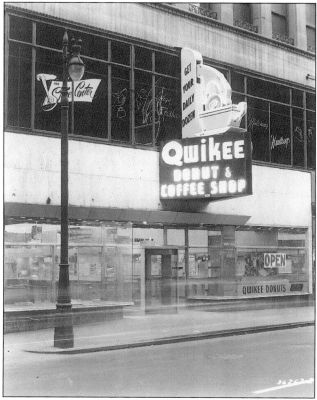

WEST GRAND RIVER AVENUE, 1953. Located at 25 West Grand River, the Qwikee Donut & Coffee shop was a well-known fixture during the downtown business day. Sharing building space with other retailers, such as "The Style Center" offering "high fashion" and "matching hand bags," was not unknown.

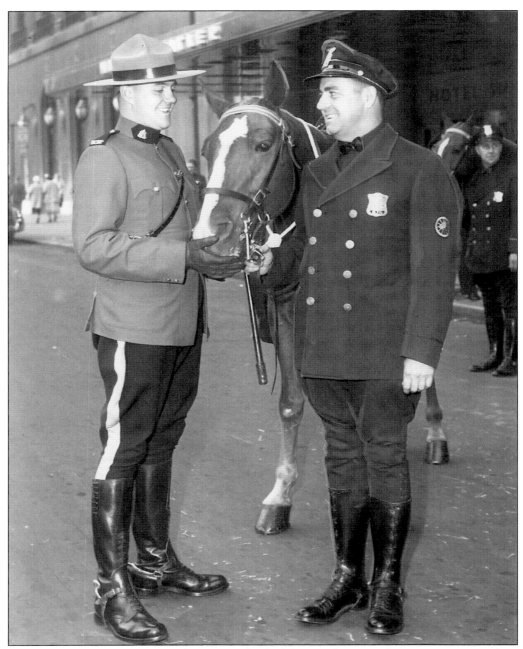

No Horsing Around, 1953. These two individuals have at least one thing in common—a love of horses. Gathered together to celebrate the International Freedom Festival, this Royal Canadian Mounted Policeman and an officer of Detroit's Mounted Section take time out to discuss the finer points of horsemanship. The Mounties enjoy a splendid history of service to Canada along with an earned reputation for diligence and professionalism. The Detroit Mounted Police have served as a showpiece for the city since 1893 and remain one of the few mounted units in the country. The Mounted Section is one of the elite units of the Detroit Police Department, known not only for their fine turn out, but for their service to the people of the city of Detroit.

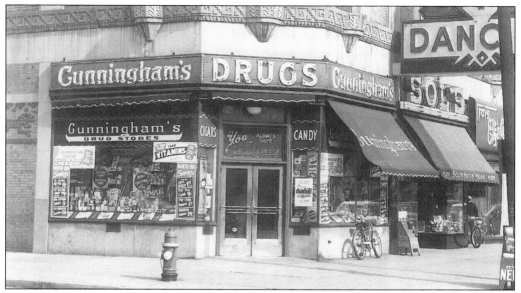

EAST JEFFERSON AVENUE AND NEWPORT STREET, 1950S. Founded by Nate Shapero, Cunningham's Drugs Stores have been a Detroit landmark since the 1930s. A forerunner of the modern convenience store, Cunningham's served the everyday needs of Detroiters with everything from pharmaceuticals to sodas. Some of the month-end savings included rat-tail combs for 9¢ and 100 aspirin tablets for 8¢.

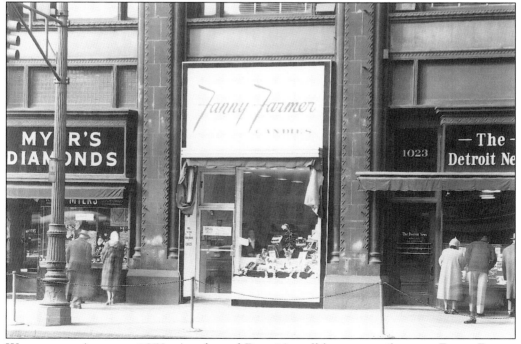

WOODWARD AVENUE, 1953. Another of Detroit's well-known retailers was Fanny Farmer Candies. This store in the 1000 block of Woodward remained a constant in many downtown dwellers' lives. The delicious window displays caused many a nose print to be left on the glass window. This display is set up for the Easter holiday.

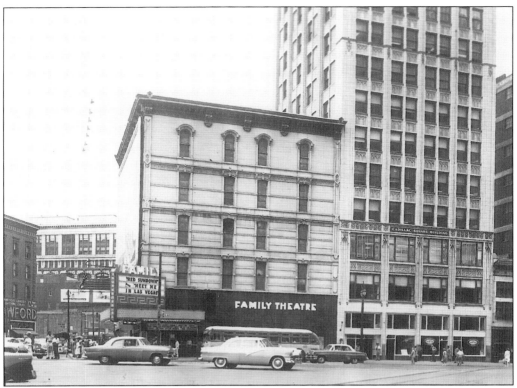

WOODWARD AVENUE AND CADILLAC SQUARE, 1950S. A landmark on this corner since the early 1900s, the Family Theater started out life as a part of the old Kirkwood Hotel. First a vaudeville theater, it was converted to movie presentation in 1914 and had 934 seats. It was destroyed by fire in 1973.

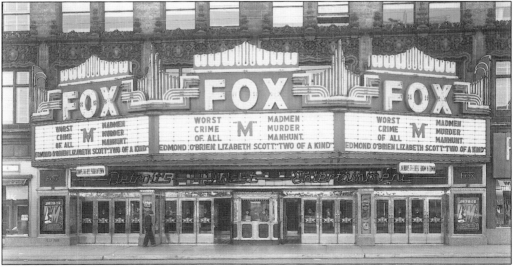

WOODWARD AVENUE, 1950S. The Fox Theater was the last motion picture palace to be built in downtown Detroit. Still offering "Detroit's Finest Entertainment," this was theater's marquee throughout the 1950s. Promising "always the best show in town" since 1928, the Fox remains the standard of what once was Hollywood elegance.

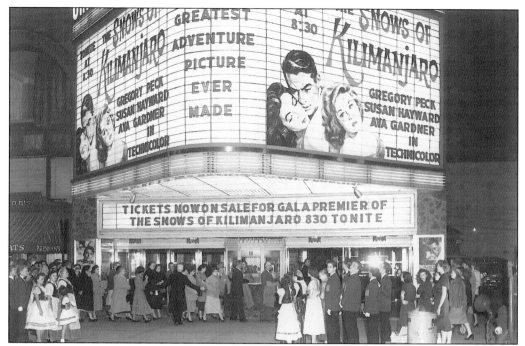

BAGLEY AVENUE, 1950S. A huge marquee announces the gala premiere of *The Snows of Kilimanjaro* at the United Artists Theater on Bagley Avenue. Movie-goers line up, while theater employees, ladies in native costumes, and gentlemen in uniforms flank each side of the ticket booth.

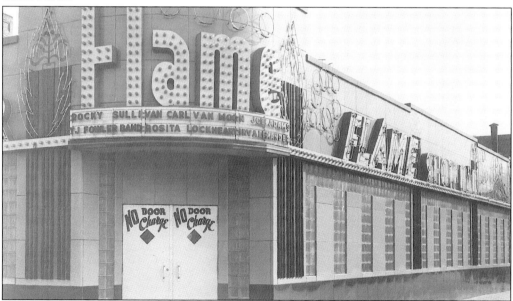

JOHN R AND CANFIELD, 1950S. The Flame Show Bar opened on June 24, 1949, and boasted 250 seats and a 1,000-foot bar. There were three or four one-hour stage shows each night except for Fridays and Saturdays when there were five. Known as "Little Las Vegas" there was a new headliner every week. Billie Holiday was the first in a long line of fabulous singers who appeared at the Flame.

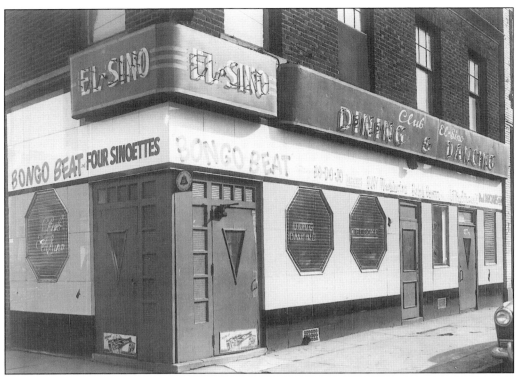

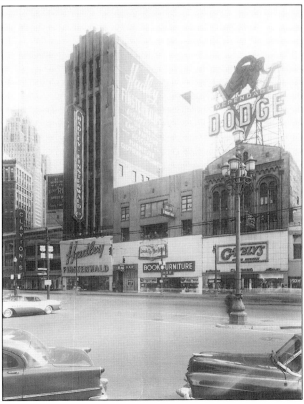

THE PLACE TO GET "BEAT" IN DETROIT, 1950S. Typical of the "beat" generation clubs of the 1950s, the El Sino club offered its patrons the "Bongo Beat" for their listening and dancing pleasure. Using their own club group, the Four Sinoettes, and starring the Bo-Do-Jo dancers, the El Sino club was the place to be for the "beatniks." Ray Washington and Ralph Brown also starred.

MICHIGAN AVENUE AND WASHINGTON BOULEVARD, 1950S. The area around the Book Building featured name-sharing retailers such as the Book Bar and the Book Furniture store at 235 Michigan Avenue. Hadley Finsterwald was a small department store offering some competition to Hudson's, while Clayton's and Gately's sold clothing. The huge "Dependable Dodge" ram looks on over all.

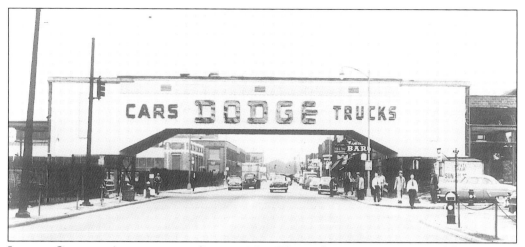

JOSEPH CAMPAU AVENUE AND CLAY, 1954. The pedestrian overpass straddling Joseph Campau tells all onlookers that they are in Dodge country. The establishments looking south along Joseph Campau catered to the blue-collared working class. They offered no-frills food and drink to their clientele. Some of the white-collared help are out for lunch.

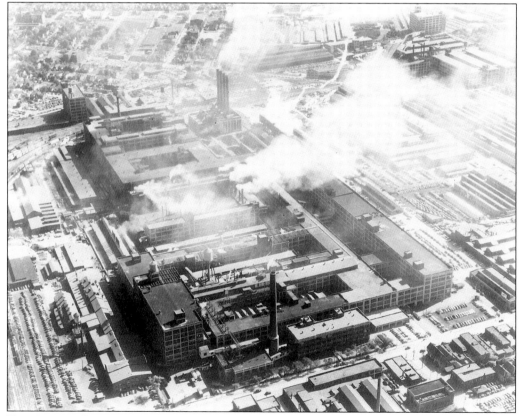

THE DODGE BROTHERS PLANT, HAMTRAMCK, 1950s. The Dodge Brothers Assembly plant on Joseph Campau Avenue in Hamtramck symbolized the might of the Motor City. Initially building transmissions for Henry Ford, the brothers formed their own car company before merging into the Chrysler Corporation in the spring of 1928 for $170 million.

EAST GRAND BOULEVARD, 1950S. After an honest day's work, these two gentlemen head home to dinner. With the influence and financial backing of a group of Detroit businessmen headed by Henry B. Joy, Truman Newberry, and others, James Packard moved his auto company to the city from Warren, Ohio, in 1902.

THE PACKARD MOTOR CAR COMPANY, 1950S. Designed by Albert Kahn, the Packard Plant consisted of 74 buildings on 80 acres of land. Building number ten, built in 1905, was the first structurally reinforced concrete factory in the world. Packard's company celebrated its golden anniversary in 1949, but sales would begin to decrease in the 1950s. Packard acquired the Studebaker Corporation in 1955.

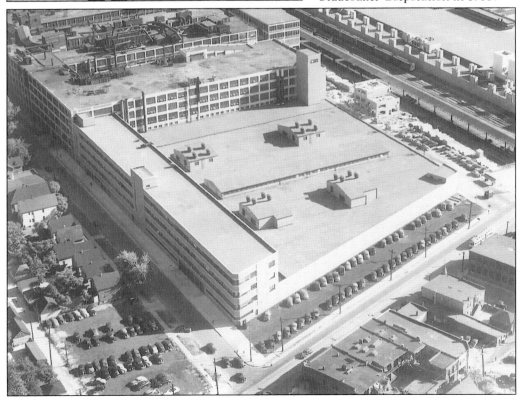

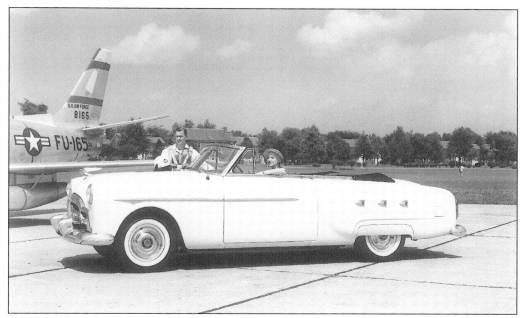

ON SILVER WINGS, 1950S. On the tarmac, possibly at Detroit City Airport, sit two beautiful birds: a United States Air Force F-86 Sabre Jet (extreme left) and a brand new Packard convertible. The F-86 would earn its wings over the skies of North Korea, while this Packard proudly displays its wings in the distinctive hood ornament.

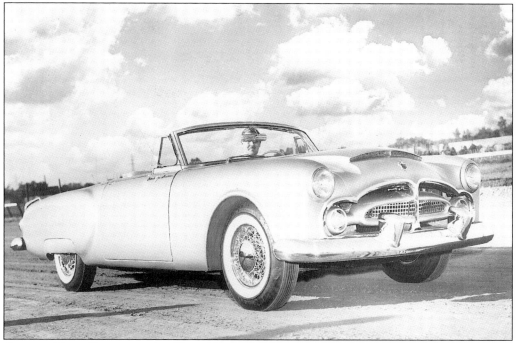

ON THE TEST TRACK, 1953. The 1953 Packard Pan-American sports car is put through its paces at the Packard test track, a 500-acre parcel of land just north of Detroit. Built by an ambulance coachbuilder, the Pan-American was produced for exhibit only at auto shows. Only five were built, as the cost for production models was exorbitant.

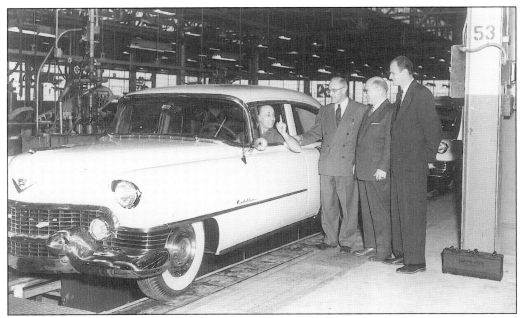

THE QUEEN OF AUTOMOBILES, 1954. Pictured here is the first 1954 Cadillac to roll off of the assembly line at the Jefferson Avenue plant; the plant management looks on approvingly. The 1954 Cadillac was a totally new design with an "egg crate" front grille and "Dagmar" bumper guards. The windshield was now a wrap-around unit. A classic example of Detroit iron.

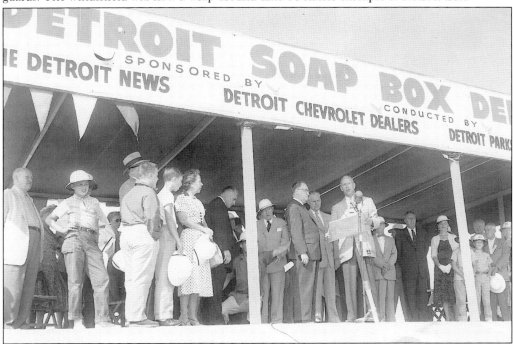

OUTER DRIVE, EAST OF MOUND ROAD, 1956. The Annual Detroit Soap Box Derby gets underway on Derby Hill, the new track in 1956. The first derby was run in Detroit in 1935, one year after the very first one in Dayton, Ohio. A steel ramp was first erected at the top of Spinoza Drive in Rouge Park.

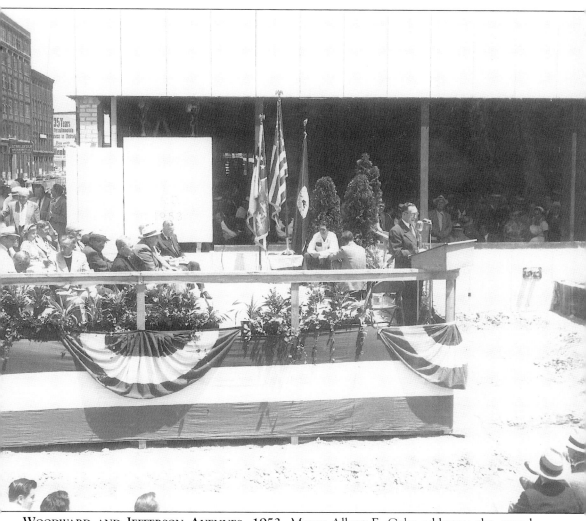

WOODWARD AND JEFFERSON AVENUES, 1953. Mayor Albert E. Cobo addresses the crowd at the laying of the cornerstone of the new City-County Building on June 24, 1953. Standing at the confluence of its two best-known highways, Woodward and Jefferson, the City-County Building rests on the site of Cadillac's landing and the first fort, called Ponchartrain, after Cadillac's patron. The City-County Building is the second building to be built in Detroit's new Civic Center, the first being the Veteran's Memorial Building. It will house the municipal offices of the city as well as the Wayne County Courts, excluding recorders court and traffic court. Detroit has been governed from the same spot since 1701.

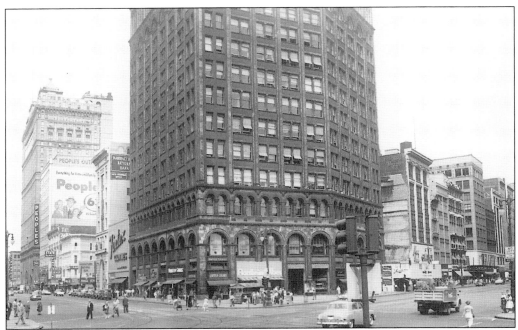

WOODWARD AND MICHIGAN AVENUES, 1956. The Majestic Building still stands, well, majestically, at the corner of Woodward and Michigan in 1956. Various retailers occupy the ground floor, while different offices are kept throughout the other floors. There appears to be a Sanders Ice Cream Parlor going in next door in this view taken from city hall. The Majestic fell to the wrecker's ball in December of 1961.

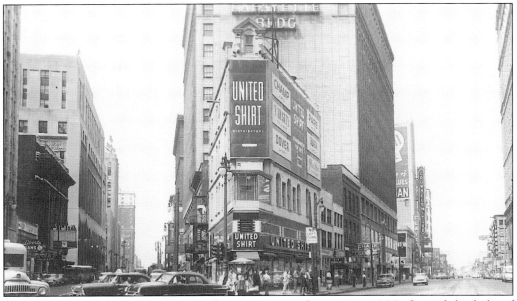

MICHIGAN AVENUE AND LAFAYETTE BOULEVARD AT GRISWOLD, 1956. One of the hubs of Detroit's radial street plan was this intersection just west of Woodward Avenue. Looking down Lafayette (left), the small marquee of the Schubert Theater, one of two legitimate theaters in Detroit at that time, can be seen. The triangular building (center) houses a United Shirt Distributor.

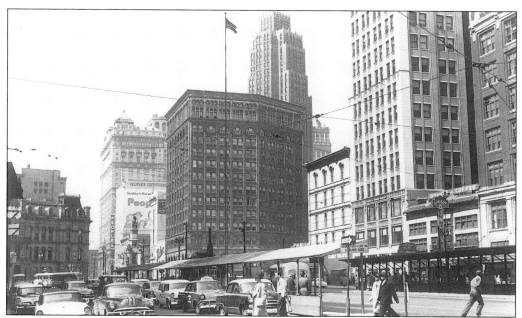

CADILLAC SQUARE, EAST OF WOODWARD, 1956. The scene on Cadillac Square reveals a variety of automobiles produced by the Big Four. A few people are still waiting for the streetcar while several buses are in the scene. Donuts and coffee are available at Speedy's (right).

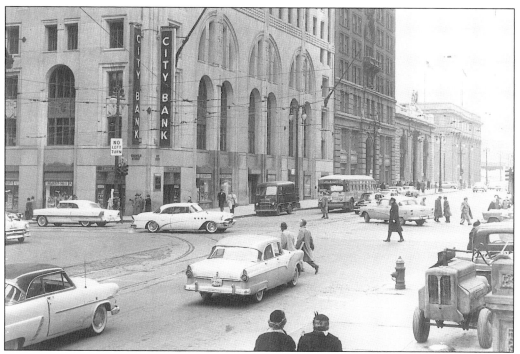

FORT STREET AND GRISWOLD, 1956. This view taken from the steps of old city hall looks west along Fort Street at the intersection of Griswold. The City Bank Building dominates the intersection, with Shapero's Drugs on the ground floor. The Fort Street side of the Penobscot Building is next, followed by two more banks in this part of the financial district.

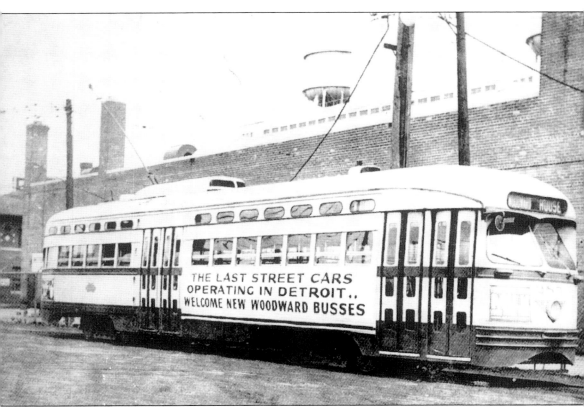

THE END OF THE LINE, 1956. Since 1863, streetcars have roamed the streets of the city, first drawn by horses, then powered by electricity. By 1952, only four rail lines were left of the once-large system: Jefferson, Michigan, Gratiot, and Woodward. In 1954, the Jefferson line was the first to go, soon followed by the Gratiot, and, in 1955, the Michigan lines. A large public relations blitz by the Detroit Street Railway failed to convince a doubting public of the convenience of the bus. The number of automobiles on the streets, making boarding and exiting the rail cars dangerous, spelled the end of the system. By the fall of 1955, it was evident that even the Woodward Line was doomed. April 8, 1956, was the last day that the streetcar found itself on the job. At 5:30 p.m., car number 237 pulled into the Woodward car house for the last time.

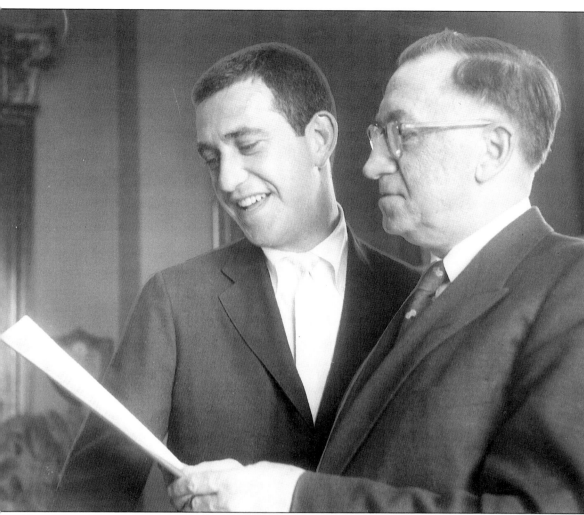

Two Well-Known Detroiters, 1955. Mayor Albert E. Cobo looks over a television script with Milton Supman, better known as Soupy Sales, before a broadcast in 1955. Born in North Carolina and raised in West Virginia, Soupy Sales came to Detroit from Cleveland in 1953 to audition for a job in television. His fourth station, WXYZ, hired him to do a show eating lunch with children. So began "Lunch with Soupy"; a lot of us grew up with that program. His trademark bow tie, sidekicks White Fang, Black Tooth, Pooky, and Iffy, not to mention the pie-in-the-face routine, entertained children from 1955 to 1966 when the show went off the air in New York.

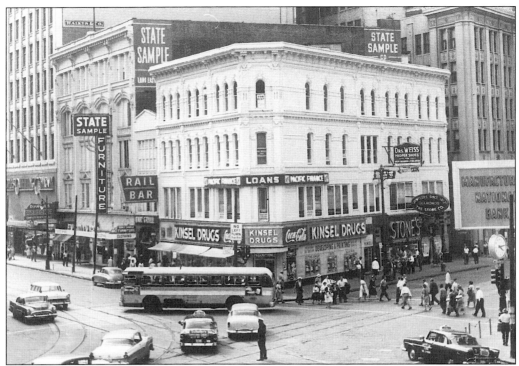

MICHIGAN AVENUE AT GRISWOLD, 1956. The trolley tracks are still in place but will soon be removed as the city streets are repaved. Kinsel Drugs sits on this corner across the street from Manufacturers National Bank. Gone are the overhead power lines for the streetcars as more and more vehicular traffic moves downtown.

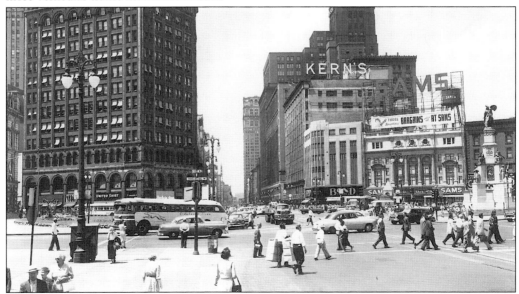

WOODWARD AVENUE AND CADILLAC SQUARE, 1950s. The heart of the city is still the old Campus Martius, now named Cadillac Square in honor of the founder of the city. Detroiters take advantage of the beautiful weather to conduct business in the main retail district of the city. One could still get "those sensational bargains everyday at Sam's.

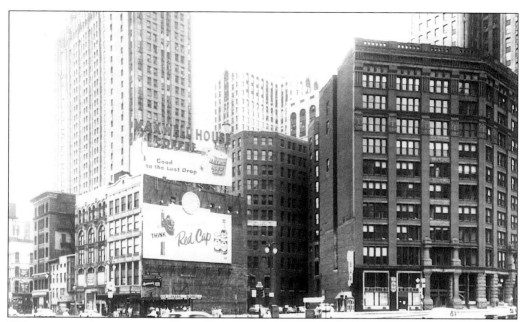

"WOODWARD AVENUE AND FORT STREET, 1957. Maxwell House Coffee is still "good to the last drop," just as the sign says on the Richmond-Backus Building on the far left of this photograph. The Union Trust Building is to the right of the sign, while the old Hammond Building maintains its place in the right foreground.

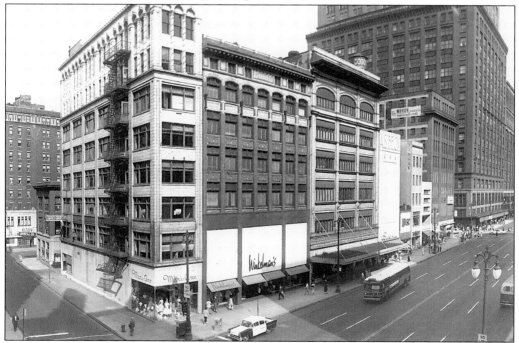

WOODWARD AVENUE AND JOHN R, 1957. Winkelman's now occupies the old Ferguson Building in this shot from the late 1950s. The Woodward Avenue buses are running on time in both directions. A new chain of women's clothing stores, Mari-Ann's, occupies a small space right on the corner, giving some competition to the larger Winkelman's.

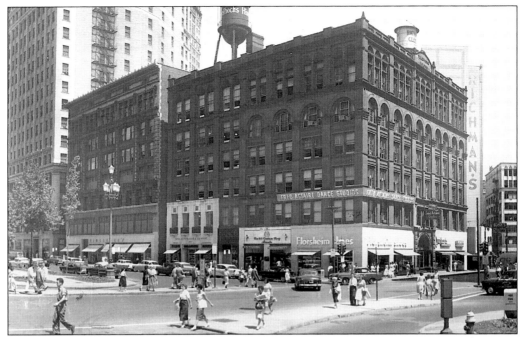

Washington Boulevard at Clifford, 1957. The Telephone Building was erected in 1911 and served the communication needs of the city for a number of years. Now known as the Clifford Building, it is the home of several retail outlets, most noticeably Florsheim Shoes. The building's upper floors are occupied by the Fred Astaire Dance Studios.

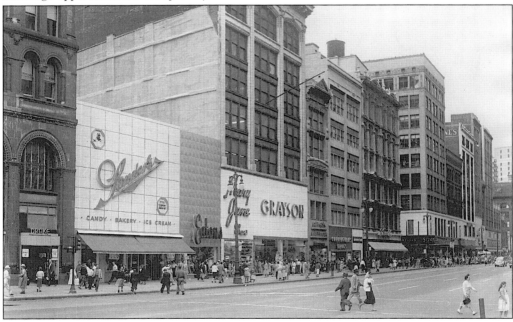

Woodward Avenue between Michigan and State, 1957. An architectural mix is evident in this stretch of Woodward from the new facades on the older buildings. That delicious Detroit standby, Sanders, appears to be in a completely refurbished structure, while Mary Jane and Grayson have new fronts in a building that once housed the Parisian Company.

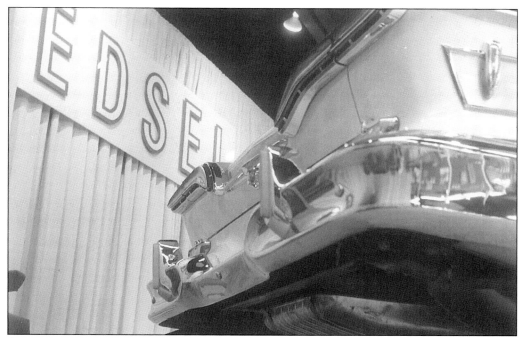

ONCE A LEMON, NOW A CLASSIC, 1957. The distinctive rear end of that much maligned Edsel can be recognized from miles away. This car was designed as a 2-ton, mid-priced monster so that Ford's customers would have something to "trade-up" to that wasn't a General Motors or Chrysler product. The model was introduced just prior to a recession and was full of bugs; it was made for only three years.

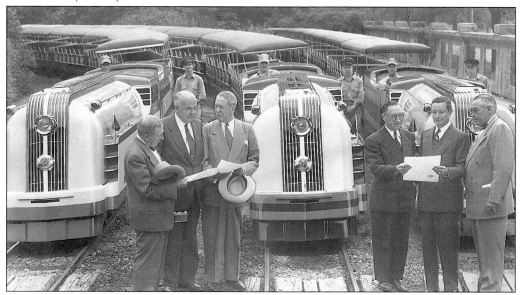

THE DETROIT ZOO, 1958. Two new locomotives and observation cars join the original *Walter P. Chrysler* in the Detroit Zoo miniature railroad. The two were named the *William E. Scripps* in honor of the man who donated the original in 1931 and the *Walter O. Briggs* in honor of the zoo commissioner. From left to right are Scripps, William T. Barbour, B.E. Hutchinson, Mayor Cobo, Walter O. Briggs Jr., and Frank G. McInnis (zoo director).

WOODWARD AVENUE, 1958. Is this Chicago or is it Detroit? On a spot windy enough to be on Lake Michigan these Detroiters hold on to their hats and children as they brave the gusty weather. Federal Department Stores, with stores in the metro area and Dearborn as well as downtown, provided stiff competition for the other retail outlets.

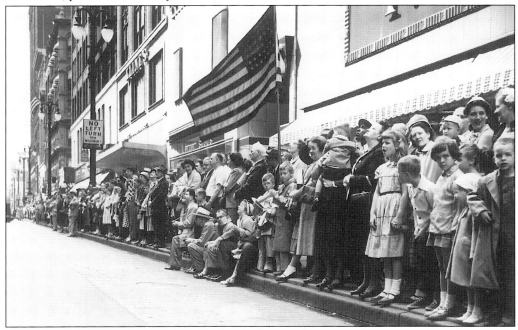

WOODWARD AVENUE, 1958. People from all over the metropolitan area line the avenue waiting for the Memorial Day parade to begin. These children look everywhere at the sights of the big city (some adults gawk as well) in front of the Kline's and the Lerner shops.

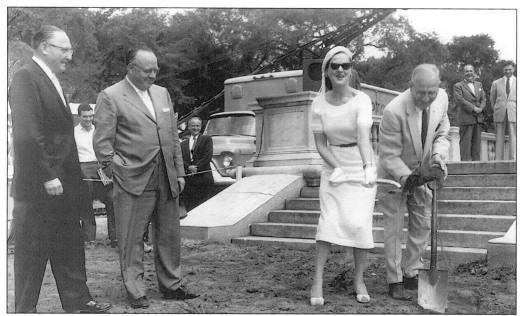

WOODWARD AVENUE AND KIRBY, 1958. Detroit Common Council president Mary V. Beck hoists a shovel full of dirt at the groundbreaking ceremony for the Detroit Public Library addition on August 13, 1958. Dr. Leon Fram, president of the library commission, and Mayor Louis C. Miriani look on, and Dr. Harvey M. Merker of the commission helps out.

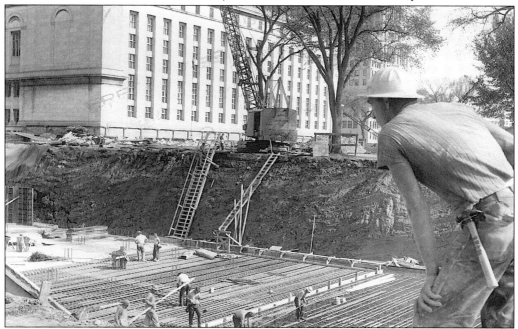

STEADY PROGRESS, 1958. Construction of the addition continues with the laying of the flooring for the second basement level on the Cass Avenue side of the library. The two wings would house the children's library and the Burton Historical Collection on the Kirby side and the sociology and economics, the philosophy, religion, education, and the science and technology departments on the Putnam side.

101

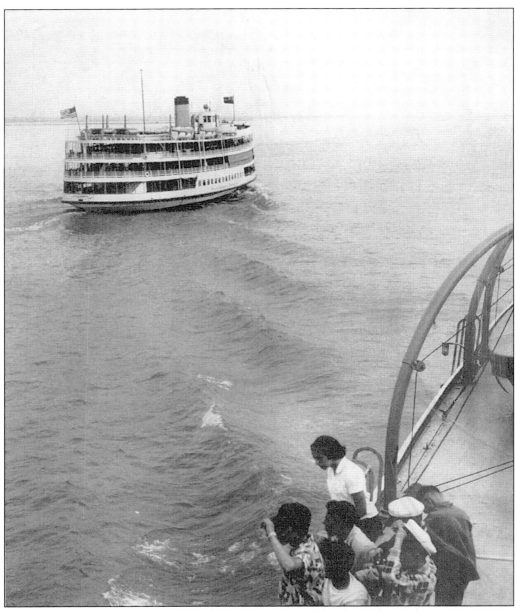

THE DETROIT RIVER, 1959. Perhaps the most famous and familiar sight on the Detroit River is this one of the two chubby steamers of the Bob-Lo Excursion Line passing each other on their way to and from the Canadian amusement park on Bois Blanc, or Bob-Lo Island. A great part of the romance of the island lay in getting there on the Bob-Lo boat. The cruise took just over an hour from the foot of Woodward. There were also moonlight cruises available on these boats, and they would sail up and down the river with the latest dance bands playing on the second deck.

Four

THE 1960s

JEROME P. CAVANAUGH, MAYOR OF DETROIT, 1960–1967. A native Detroiter, Jerome Patrick Cavanaugh was the second youngest person ever elected Detroit mayor, having been elected to the city's highest office at the age of 33. In his first bid for elective office, Cavanaugh won in an upset victory over incumbent Louis C. Miriani, and he was reelected in 1965. Cavanaugh also presided over the riot in 1967. Among his achievements were the elimination of a $34.5 million deficit; the reduction of the property tax rate; the implementation of affirmative action programs, accelerated programs of urban renewal, and neighborhood conservation; and the expansion of the Cultural Center, with additions to the Institute of Arts and the Historical Museum. Under his leadership, Detroit was the sole American city to bid for the 1968 and 1972 Olympic Games.

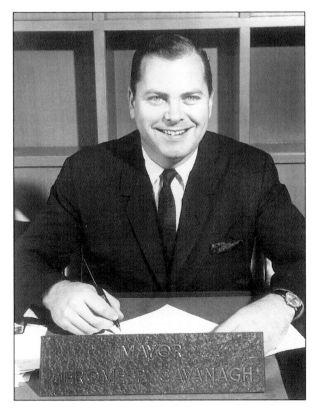

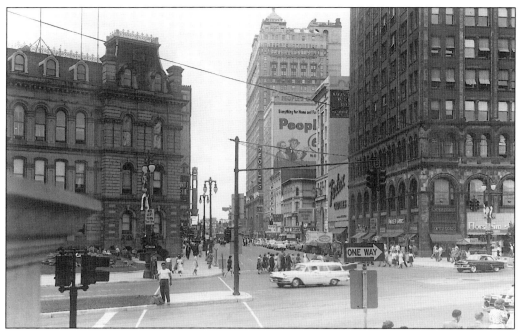

WOODWARD AND MICHIGAN AVENUES, SUMMER 1960. This corner would be dramatically changed in the next two years, but for now it remains a recognizable intersection. A lot of Detroiters work and shop downtown and the area is alive. By 1962, the city hall (left) and the Majestic Building (right) would be torn down.

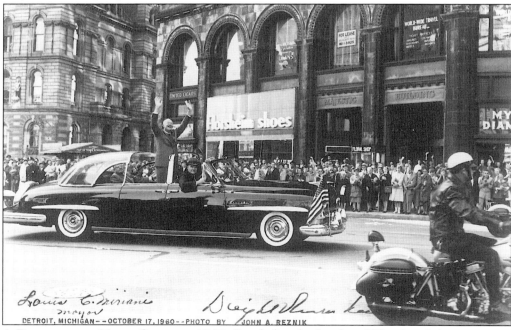

A PRESIDENTIAL VISIT, OCTOBER 1960. People line both sides of Woodward Avenue to see Pres. Dwight D. Eisenhower on his visit to the Motor City. Mayor Louis C. Miriani is in the back seat accompanying "Ike" in this small motorcade. It is an election year, and the ex-general of the Army is rallying his Republican Party troops.

THE BEGINNING OF THE END, 1961. The old city hall at Woodward and Michigan stands empty and nearly windowless after numerous attempts by the City of Detroit to find buyers or tenants for the venerable old landmark. Construction of the building began with the cornerstone laying in 1871, and the structure served as the seat of city government until 1956.

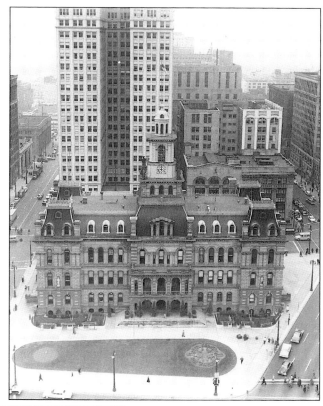

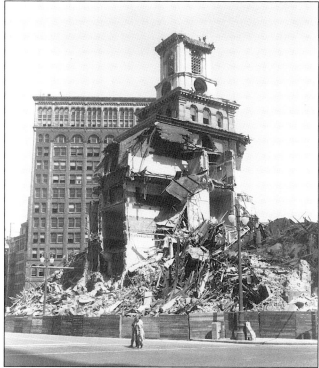

ANOTHER ONE BITES THE DUST, 1961. The wrecking ball does its dirty work on the 85-year-old city hall building. The central steeple and clock tower are all that remain to knock down. The four statues that graced the building now adorn the campus of Wayne State University. They depict Cadillac, Marquette, La Salle, and Gabriel Richard.

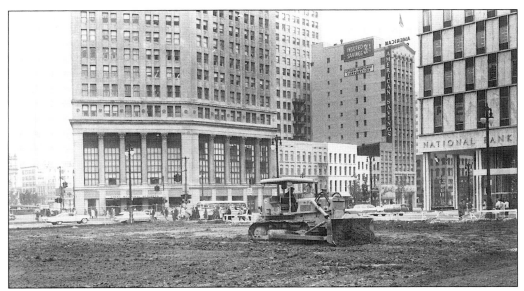

JUST A MEMORY, OCTOBER 1961. A bulldozer fills in the last scars of city hall's demolition in the fall of 1961. The heart of the city's banking district is evident in this view of the National Bank of Detroit (right) and the First National Building (middle). The city planted a flowerbed until the Kennedy Square underground parking structure was built.

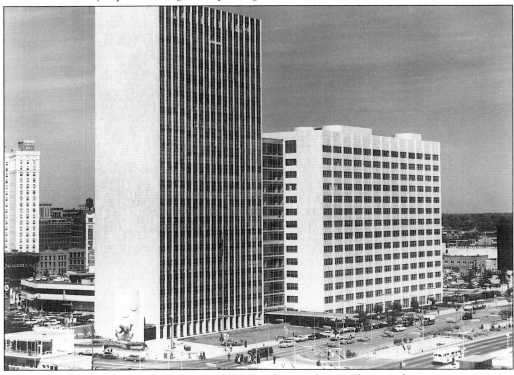

WOODWARD AND JEFFERSON AVENUES, 1960S. The new home of city and county government gleams in the sun, as the Civic Center area of the city becomes a reality. Designed to be in harmony with the Veteran's Memorial Building, the City-County Building provided office space for some 4,000 people. Cost estimates reached $26 million.

WOODWARD AND MICHIGAN AVENUES, 1961. The next Detroit landmark to fall to the wrecking ball would be the Majestic Building at the corner of Woodward and Michigan, opposite the Campus Martius. Built in the 1890s, the Majestic housed retail and professional businesses and served as a contemporary companion to the city hall.

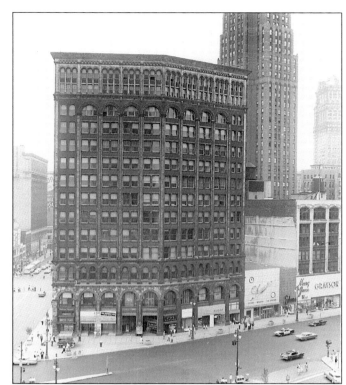

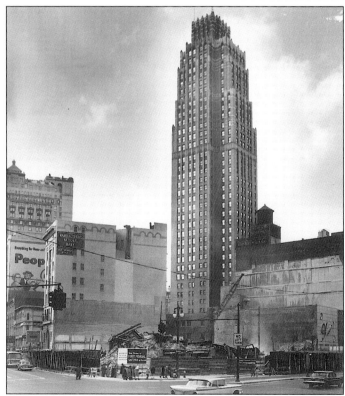

JUST ANOTHER MEMORY, DECEMBER 1961. The David Stott Building looms over the site of the Majestic in mid-December 1961. The wreckers have managed to bring the building down without damage to the rest of the block (to the eternal gratitude of Sanders patrons). The First Federal Savings Bank of Detroit will be here instead.

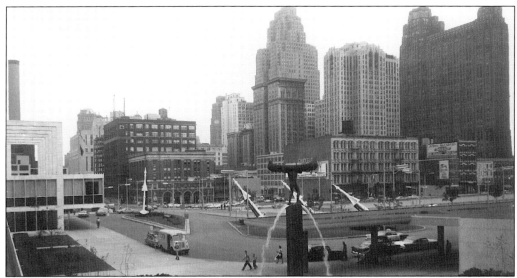

JEFFERSON AVENUE NEAR WASHINGTON BOULEVARD, 1962. An Algonquin Indian portages his canoe, and Nike missiles stand ready to launch in this display of American readiness in the midst of the Bay of Pigs crisis. The Penobscot Building with its distinctive red globe occupies center stage. This shot was taken from the new Cobo Hall.

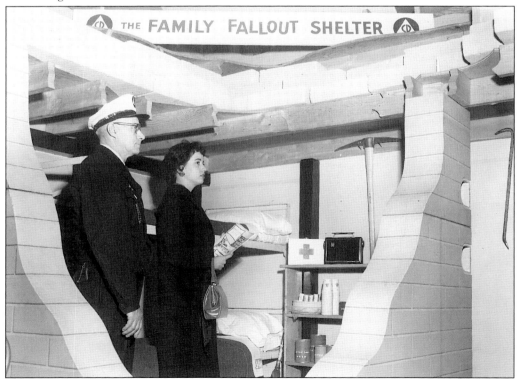

THE LATEST IN HOME DEFENSE, 1962. The annual home show featured exhibits ranging from swimming pools to power mowers, but no exhibit was more visited than this model family fallout shelter, or bomb shelter. This Civil Defense captain shows off the latest model that could be constructed in your basement or backyard.

WOODWARD AVENUE, LOOKING SOUTH, 1963. The easily recognizable rear-end of a Chevrolet Impala graces the right foreground of this photo, looking south toward the river. The slowly changing cityscape that is Woodward is evident here. Old buildings have new signage and paint work and, in some cases, completely new facades. On a clear day you could see the river.

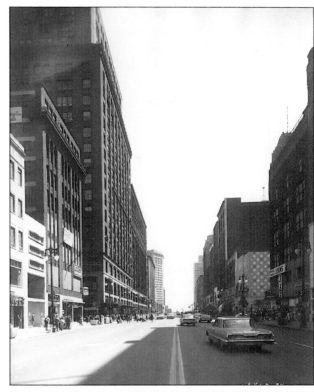

CAMPUS MARTIUS AT NIGHT, 1960s. Downtown shopping at night was easy with streets lit by retailers until 9 p.m. Long an occupant of the Campus Martius, Sam's Cut Rate has its display windows full and aglow with light. The center display contains women's fashions, and one could always find a deal in the "bargain basement."

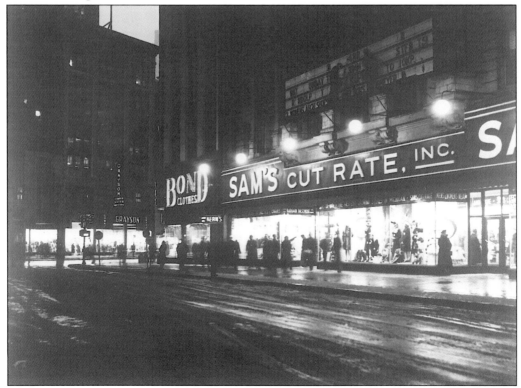

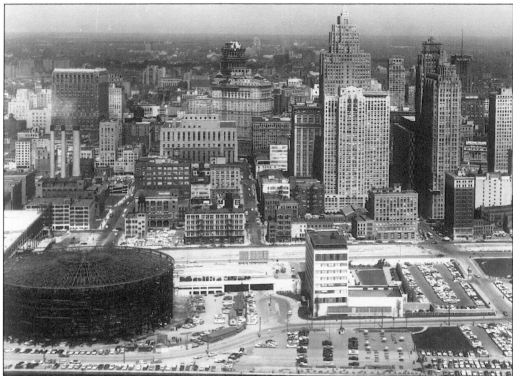

THE DEVELOPING RIVERFRONT, 1960S. This aerial shot taken from high above the Detroit River catches the construction of Cobo Hall as the latest development in the Civic Center area. Businesses along an ever-widening West Jefferson Avenue are a mixture of warehouses, small manufacturers, and hotels. All are soon due for remodeling or demolition.

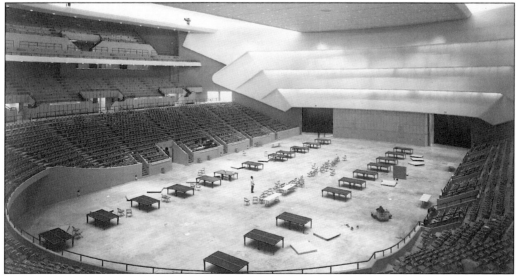

THE COBO HALL CONVENTION ARENA, 1960S. This interior shot shows the Cobo Hall Convention Arena set up for a ping-pong competition sometime during the early 1960s. During this time period, the Detroit Pistons basketball team would make the arena their home, coming over from the more expensive Olympia and the smaller University of Detroit court.

110

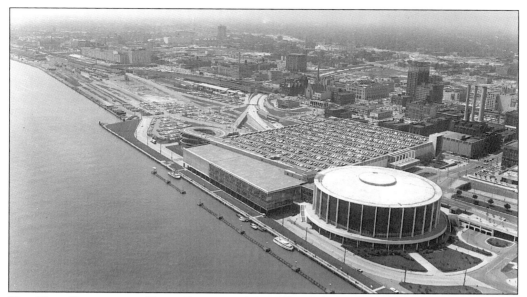

THE NEW RIVERFRONT CIVIC CENTER, 1960S. The Cobo Hall rooftop parking looks to be full either for a sporting event or a convention. The breakwater lying parallel to the Cobo Hall complex allowed small pleasure craft the luxury of tying up at the dock. The building in the middle distance is the Michigan Central Railroad Depot, while to the right one can barely discern Tiger Stadium.

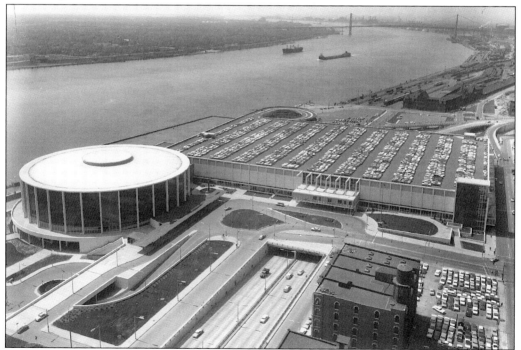

THE DETROIT RIVER, 1960S. Built at a cost of $53 million, the Cobo Hall Convention complex adorns the riverfront at the foot of Washington Boulevard. Two types of river commerce are present: a freighter and a Great Lakes ore carrier. The yard of the Michigan Central Railroad lies just above the hall.

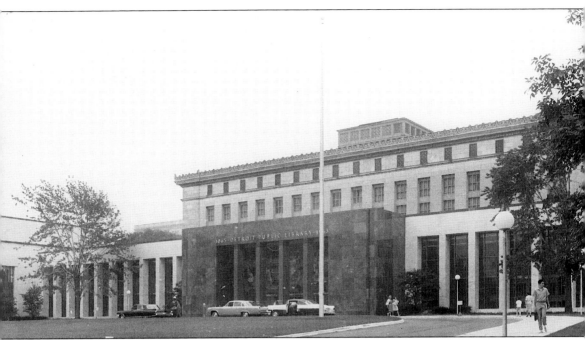

CASS AVENUE AND PUTNAM, 1960s. The distinguished new addition to the Detroit Public Library is complete, adding an important new façade to Cass Avenue. Francis Keally and Cass Gilbert Jr. were the architects for the new wings. Cass Gilbert Sr. was the architect for the original building, started in 1914 and finished in 1921. The enlarged structure, built at a cost of $10 million, more than doubled the size of the original building and provided four additional floors in each wing, two underground and two above ground. Each wing is 90 feet by 245 feet, which means a half-acre to each floor, 4 acres in all. The library staff moved over 1,297,411 books from the old part of the building into the new.

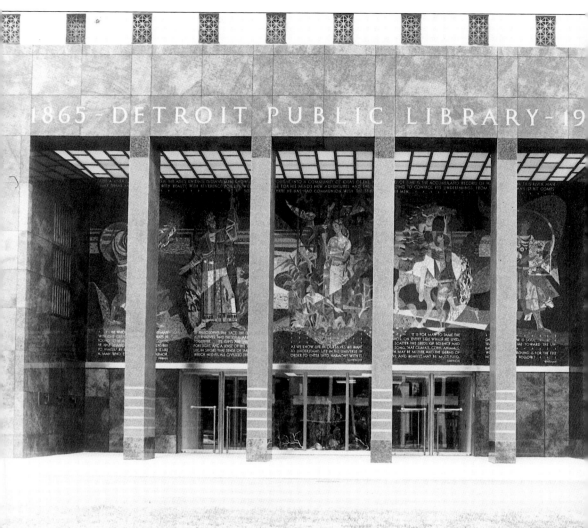

The Cass Avenue Entrance, Detroit Public Library, 1960s. A $40,000 gift of the Edwin Austin Abbey Fund, administered by the National Academy of Design in New York, provided the brilliantly colored glass mosaic mural over the Cass Avenue entrance. Millard Sheets, a California artist, designed the 16-foot-by 40-foot mural, which depicts the services of a library in five groups of allegorical figures, each with an appropriate literary quotation, in the foreground, and with a symbolic river of knowledge in the background. The inscription reads as follows: "Like a river flowing through the ages uniting distant men, knowledge and thought into a community of ideas of the world and of time is the accumulated record of mankind. From this river man may drink and fill himself with beauty, with reverence for life, with knowledge for his mind's new adventures and the understanding to control his undertakings. From this river man's spirit comes refreshed, for here he has had communion with the spirits of other men."

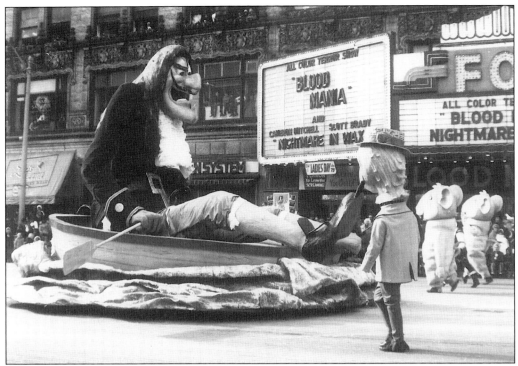

WOODWARD AVENUE, THANKSGIVING, 1960s. Captain Hook rows his way down Woodward in the annual J.L. Hudson's Thanksgiving Day Parade. He must be laughing in delight at the Fox Theater marquee. What two more appropriate movies for a bloodthirsty pirate than *Blood Mama* and *Nightmare in Wax* could appear on the same bill?

THE CHRISTMAS SEASON, 1963. Special Detroit Street Railway buses were assigned to transport people to the Christmas Carnival at Cobo Hall from all parts of the metropolitan area. These two gentlemen are either very young at heart or just need a lift to the Cobo Hall area. The Christmas Carnival was a delight for children of all ages.

WOODWARD AND JEFFERSON AVENUES, 1963. What better way to celebrate the Christmas season than with a gigantic, brilliantly lit Christmas tree. This is the Municipal Tree on the lawn across the street from the City-County Building. The annual tree-lighting ceremony drew large crowds to watch the mayor throw the switch.

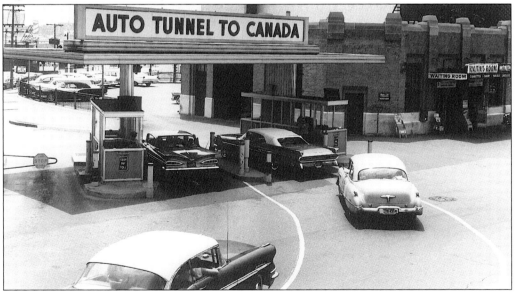

THE DETROIT-WINDSOR AUTO TUNNEL, 1960S. The set-up appears unchanged since 1930, when the tunnel to Canada opened. The cars have certainly changed; the tollbooths and sign are also new. The Tunnel Company office buildings in the background have been rebuilt. All for the greater comfort of the commuter, the tunnel still offers easy access to Windsor, Ontario, Canada.

THE DETROIT RIVER AT THE FOOT OF WOODWARD, 1965. Detroiters have been sailing to Bob-Lo since 1898, when the Steamer *Promise* took picnickers to the island. Bob-Lo was the best pronunciation of *Bois Blanc* that non-French locals could give, and it stuck and became official in 1949. The island was transformed into an amusement park in 1949.

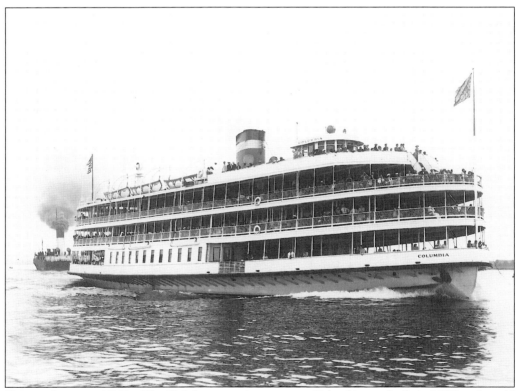

TO THE ISLAND, 1960s. The Bob-Lo excursion steamer *Columbia* was built in 1902 and could hold 2,500 passengers. There was a dance floor on the second deck and a beer garden on the third. When the *Columbia* started her service, there was a carousel and a dance hall designed by Albert Kahn that served as the simple attractions of the island.

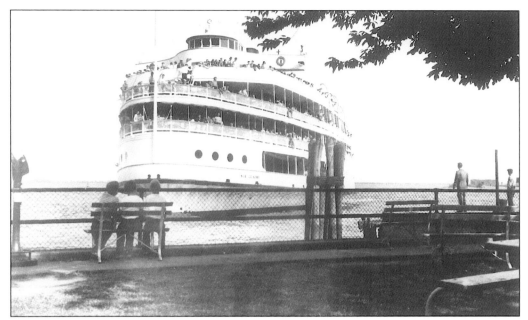

AT THE ISLAND, 1960S. The Bob-Lo Excursion Line steamer *Ste. Claire* makes her turn in preparation for docking at Bob-Lo. The *Ste. Claire* was built in 1910 as a sister ship to the *Columbia* and could also transport 2,500 passengers. Both boats carried as many as 800,000 visitors to the island yearly in the heydays of the 1950s and 1960s.

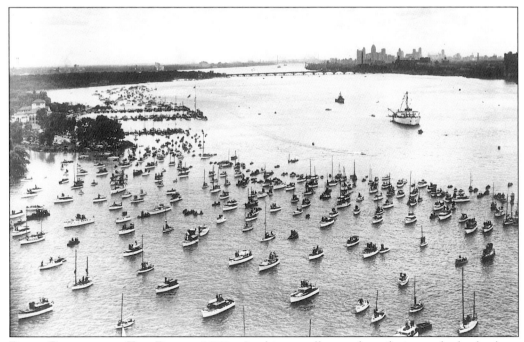

RIVER REGATTA OR TOY BOATS, 1960S. Looking small enough to fit into a bathtub, these pleasure craft gather at Belle Isle to watch the arrival of a tall ship. In the middle distance can be seen the General Douglas MacArthur Bridge, while at the left is the Detroit Yacht Club facility.

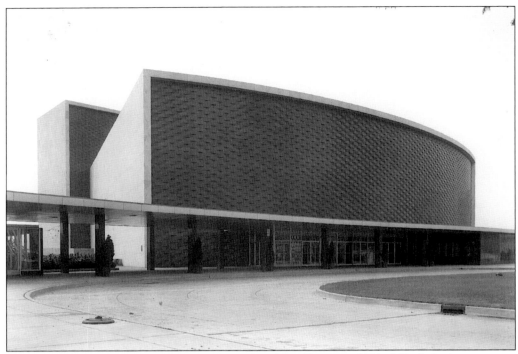

JEFFERSON AND WOODWARD AVENUES, 1960s. The Henry and Edsel Ford Auditorium was built at the foot of Woodward and the Detroit River as a part of the new Civic Center with funds raised by the Ford dealers during the 250th birthday celebration. The structure was completed in 1956. The auditorium was designed for such uses as concerts, lectures, television and radio broadcasts, motion pictures, and conventions.

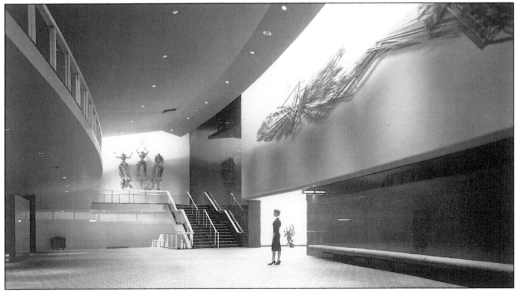

NOT A BAD SEAT IN THE HOUSE, 1960s. The stunning foyer of the Henry and Edsel Ford Auditorium is adorned with metal creations by renowned sculptor Marshall Fredericks. The auditorium has a seating capacity of 2,926—1,848 on the main floor and 1,078 in the balcony. There is also an underground parking garage for 750 vehicles.

AN HISTORIC VISIT, 1960S.
Michigan governor George
Romney shares the podium
with Vice Pres. Lyndon Baines
Johnson after the unveiling
of a plaque commemorating
the 100th anniversary of the
Emancipation Proclamation at
Detroit's Second Baptist Church
at 441 Monroe Avenue. The
church served as a station on the
Underground Railroad.

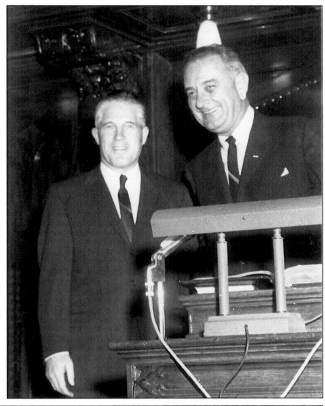

THE LABOR DAY PARADE, 1960S. Detroit's Annual Labor Day Parade is always well attended
by workers, dignitaries, state and city officials, and their supporters. Included in this line-up
are Mayor Jerome P. Cavanaugh, Gov. George Romney, former governor G. Mennen "Soapy"
Williams, and former mayor Louis C. Miriani. Debbie Reynolds stars as *The Unsinkable Molly
Brown* at the Adams.

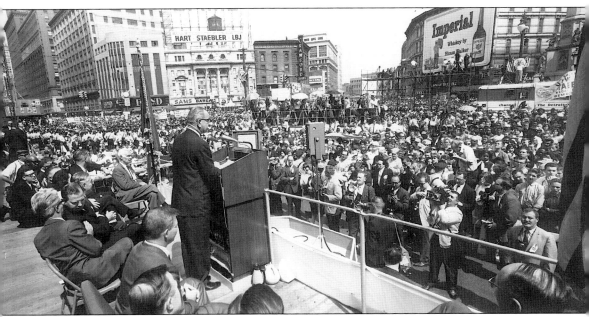

A PRESIDENTIAL VISIT, 1964. The old Campus Martius has served as a meeting place for Detroiters since the 1850s, and in 1964 they naturally gathered there again to hear Pres. Lyndon Baines Johnson give a speech in support of the Democratic Party's bid for the Presidency to a group of United Auto Workers (UAW) members. The sign urging people to vote Hart-Stabler-LBJ stands atop Sam's Cut Rate Department Store, which still holds its place in between Bond Clothes and Crawford's. The Family Theater is practically dwarfed by the Hiram Walker sign, and the Crowley's Building can be seen in the middle distance. It is curious to note the two speech prompters directly in front of the President's podium; they appear to have a continuous roll of paper with Johnson's speech on it.

DETROIT'S FINEST MEETS HOLLYWOOD'S FINEST, 1965. *Car 54* is finally found and at Metropolitan Airport of all places. Joe E. Ross and Fred Gwynne, who play Toody and Muldoon in the NBC series *Car 54 Where Are You?* were in Detroit to promote the comedy. Officer Lloyd Hewitt (left) and Rudolph Vidmer (at the wheel) drive Detroit's version of the television patrol car.

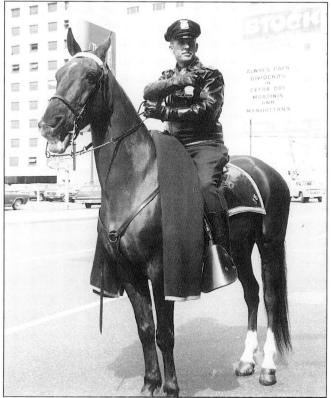

THE HORSE IS A HAM, 1966. Officer Glen Sells strikes a professional pose while his trusty steed expresses his opinion of the picture taking by sticking out his tongue. Made up of dedicated troopers, the Detroit Mounted Division has been the pride of the Motor City for 106 years. One can almost hear the raspberries.

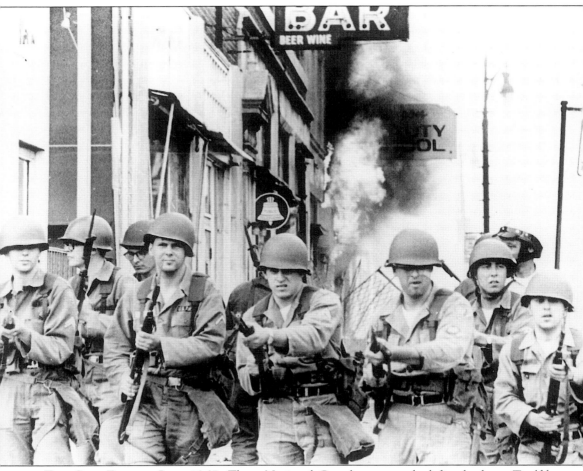

THE CITY ERUPTS, JULY 1967. These National Guardsmen march defiantly down Twelfth Street in an exaggerated show of discipline and might. On July 23, in the middle of a summer heat wave, Detroit Police decided to bust a "blind pig," an illegal after-hours saloon on Twelfth Street, in the center of one of Detroit's largest African-American neighborhoods. Arrests for illegal drinking were common in the city, and police would usually arrest a few and disperse the crowd. This time they decided to arrest and detain all 85 people present outside of the saloon. Nearly 200 people gathered to watch the proceedings, and, as allegations of police brutality were shouted, the crowd began to jeer and throw bottles, cans, and rocks at police. By 8 a.m., a crowd of over 3,000 had gathered.

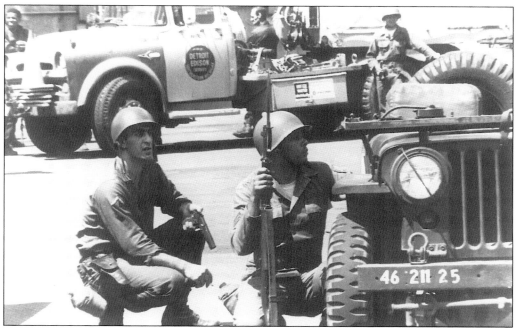

LOOKING FOR SNIPERS, 1967. Two members of the National Guard keep a wary eye on the rooftops as they guard Detroit Edison workers who are trying to restore power in the riot-torn sections of the city. Armed citizens prevented government officials and workers from restoring order to the city.

A BREAK FROM THE TENSION, 1967. These combat veterans of the 82nd Airborne Division take a lunch break from their riot duties on Detroit's eastside. Ordered into the strife-torn city by President Johnson, the federal troops did much to restore order by their professionalism, discipline, and dignity. In his nationwide address, Johnson made no fewer than seven references to Governor Romney's inability to control his own state.

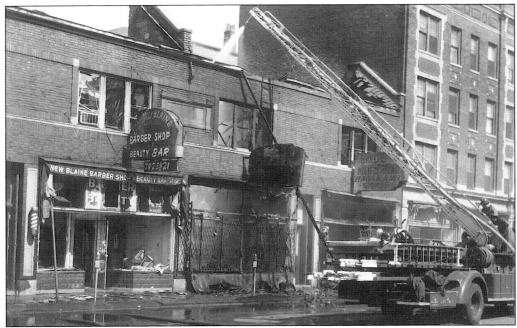

PUT THE FIRES OUT, 1967. The Detroit Fire Department works feverishly to contain the fires in the Twelfth Street area. Nearly every response was met by a shower of rocks and bricks as the firefighters attempted to battle both the blaze and their fellow citizens. Arson spread over a 10.8-square-mile area of the city's West Side.

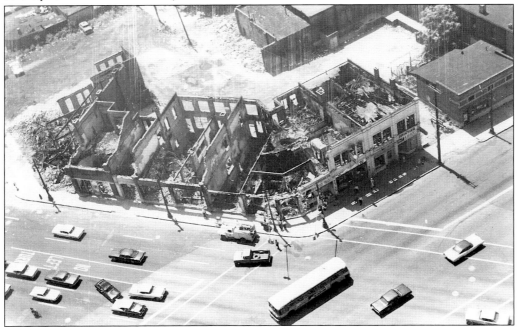

WARREN AND GRAND RIVER AVENUES, 1967. An aerial photograph of some of the riot-torn neighborhoods of Detroit make the city look as though it had been through a real war; some compared it to the Berlin of 1945. A fire started in one part of a block soon spread to the entire row of buildings.

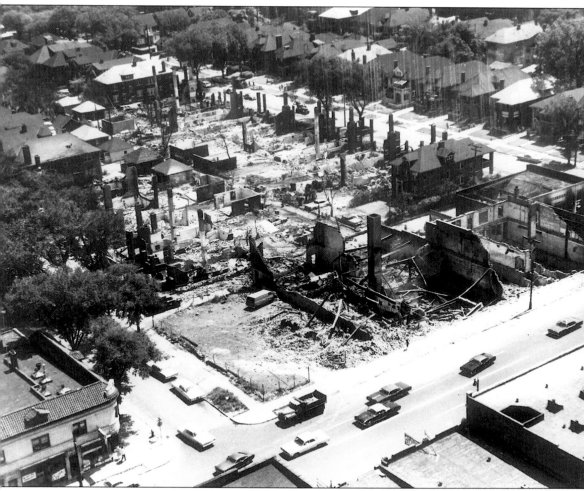

PHILADELPHIA AVENUE, 1967. This residential section along Philadelphia Avenue contained homes of some relatively prosperous African Americans, but urban violence makes no exceptions. Detroit was the scene of the bloodiest uprising in the country's history and the costliest in terms of property damage. For five days and nights, Detroiters took to the streets in an orgy of looting, arson, and sniping that left 41 known dead, 347 injured, and 3,800 arrested. Some 5,000 people were homeless (the vast majority of them African American), while 1,300 buildings had been reduced to mounds of ashes and bricks and 2,700 businesses sacked. Damage estimates reached $500 million.

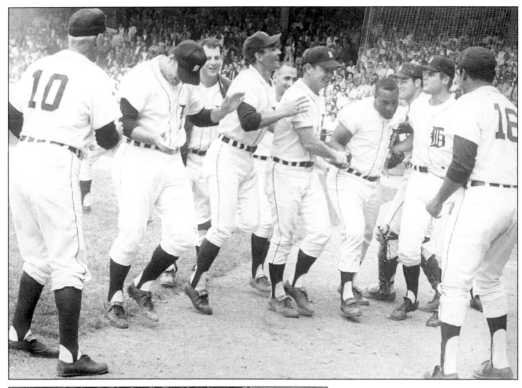

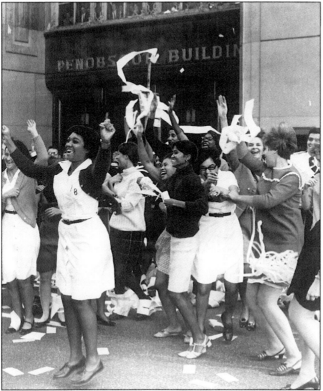

THE TIGERS TRIUMPHANT, 1968. Gates Brown is greeted by his jubilant teammates after a game-winning home run during the drive to the 1968 American League pennant. Manager Mayo Smith (10) watches the celebration, as first baseman Norm Cash is the first to offer congratulations. Mickey Lolich (29), Don Wert (8), Bill Freehan (11), and Earl Wilson (16) also participate.

A RIOT OF JOY, 1968. The city erupts in a riot of a different kind as the Detroit Tigers come from behind to capture the World Championship crown in the 1968 World Series. These office workers unite in front of the Penobscot Building to dance in the streets. The diversion of a successful pennant drive did much to heal scars leftover from the previous summer.

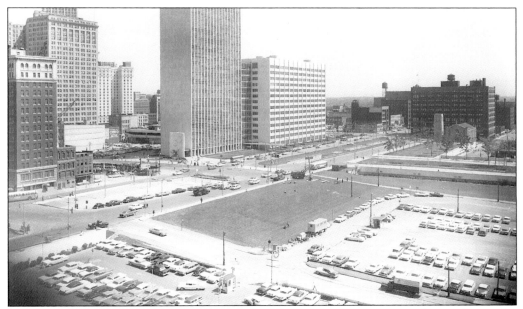

WOODWARD AND JEFFERSON AVENUES, 1969. The city returns to a sort of normalcy in the aftermath of its racial problems. This photograph, taken from the roof of Cobo Hall, shows the seat of city-county government once again in control. In the distant right is the Mariners Church, in front of buildings soon to be removed for Detroit's Renaissance.

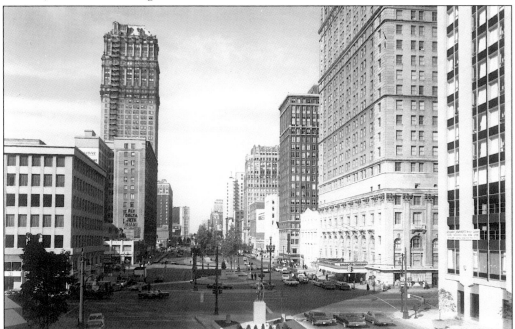

WASHINGTON BOULEVARD, LOOKING NORTH, 1969. On the verge of a new decade, Washington Boulevard looks stately with its well-manicured median and its cleaned-up statues. Gen. Alexander Macomb (foreground) faces Gov. Stephens T. Mason in front of Howard Johnson's Motor Lodge and the Sheraton-Cadillac Hotel. The United Air Lines Building (middle left) will let you "Fly Delta Jets to Miami."

A FIRE IN THE SKY, 1969. The world's largest fireworks display explodes in the nighttime sky over the Detroit skyline during the International Freedom Festival on the Detroit River. Witnessed by millions of people each year in late June–early July, the festival is a celebration not only of the country's independence but of international brotherhood and unity. Detroiters of all classes, races, and faiths gather peacefully along the riverfront to watch and wonder. The skyline of Detroit is ablaze with office lights, none standing more buoyantly than the tower atop the Penobscot Building, a longtime landmark for residents and visitors alike. As the oldest city in the Midwest begins a new revitalization, it is only fitting that the downtown area serves once again as a beacon of promise and prosperity.